PRINTS ABOUT PRINTS

DIANA EWAN WOLFE

MARTIN GORDON, INC.
New York

Exhibition arranged by Martin Gordon, Inc., and Sigma Art Fund

Text by Diana Ewan Wolfe

Photos by Trudy Schlachter

Typeset by Catherine Graphics, Inc.
New York

Printed by Halliday Lithograph
An Arcata Company
West Hanover, Massachusetts

Martin Gordon, Inc.
25 East 83rd St.
New York, N.Y. 10028
Printed in the United States of America
ISBN O-931036-07-0

CONTENTS

PREFACE

Martin Gordon began collecting the works presented here several years ago. Prints showing people looking at prints or making prints appealed to him, and he thought it might be fun to collect them. When he began doing it, he had no idea where it would lead. His enthusiasm spread, and soon one print had turned into a sizable collection. He thought they might make an interesting exhibition some day. He envisioned a simple display of the prints with an accompanying checklist. At some point, he showed the works to me. When I suggested someone ought to do a study of them, the present catalogue was born. Others who like prints can now learn more about this group of works and share Martin Gordon's enthusiasm for them.

I am deeply grateful to Martin Gordon for letting me undertake the catalogue and for his confidence in my ability to carry out the work. He gave me a free rein in the presentation of the material, took my advice on new print acquisitions, and allowed me final selection. I cannot thank him enough.

I am obliged to many other individuals for their contributions to this catalogue. I wish to express special appreciation to Estelle Whelan, who edited the bulk of the manuscript, greatly improving it. Marsha Morton, Kathryn Moore Heleniak, and James Ward provided useful comments on specific prints. Elizabeth Roth, Keeper of Prints at the New York Public Library, made my task easier by her aid in ferreting our sources on little-known artists. Dean Weber gave valuable advice in the final stages. The members of the staff of Martin Gordon, Inc., contributed in many ways. In particular, I wish to thank Stacey Gershon, Philip Adler and Thomas Wolf for their assistance. The enthusiasm of Martin Gordon's associate, Judith Goldberg, for the project was a continuing help. Finally, my thanks go to Melvin Derwis for his encouragement and to Nancy Hall-Duncan for her many constructive suggestions.

INTRODUCTION

Like artists in other media, printmakers occasionally incorporate the medium itself into the subject of their works. The purpose of this exhibition is to bring together for the first time a selection of the many prints that have been done with a print-related theme. These works merit attention as excellent documents of the changing attitudes of printmakers toward their own work and of the public toward prints.

Self-reflexive art in general is interesting because of the multiple levels of meaning in a given work. What is unusual in prints about prints is that the works themselves come in multiples. This affects their purpose by making them well-suited to advertising. Thus many of the print-related scenes promote other prints. Another special feature is that the printmaking process forces one to work with mirror images, drawing the reverse of what is to be shown. This may help to explain why so many printmakers, whether for advertisement or not, have done works referring to their own art form.

The seventy works selected constitute a representative sampling of the three hundred or more known European and American prints with a print-related theme that have been made during the last three centuries, from 1700 to the present. The largest number date from the late 19th century, when this type of print was most popular. More than half of the works exhibited are by French artists, the French having been most strongly attracted to prints about prints. The works represent the efforts of major and minor artists—artists known as much for their paintings as for their prints, artists known primarily for their prints, and artists who are scarcely known at all.

The many different types of scenes shown have in common the depiction of prints or an aspect of printmaking. Thus representations of visitors at print galleries and of collectors leafing through their print portfolios find a place beside depictions of printmakers and printers at work. There are also formally posed portraits of printmakers.

The graphic media represented cover a wide range. Etching and lithography appear most often. Some artists preferred aquatint or drypoint, while others relied on woodcut or wood engraving. The earliest in the group worked in mezzotint.

Of the works done on commission to promote other prints, the advertisements for print galleries and exhibitions are especially numerous. These are significant for the light they shed on the history of how dealers and artists have put their names and works before the public. Other commissioned works that have similar requirements, and are also included, are frontispieces to books on prints and covers for print albums. Some of the works are caricatures.

With minor exceptions, the prints in this exhibition are arranged chronologically. They start with the 18th century because earlier works with a print theme are rare and unavailable. Printmaking began in the West in the 1400s; the first known print with a print theme dates from 1568. This was a representation, from a German book of trades, of a man making a woodcut.[1] Other early works on the theme also show anonymous craftsmen at work.[2] By the 1700s, the status of the printmaker had risen: Our exhibition begins with formal portraits of printmakers shown as gentlemen (see nos. 1, 3, 4).

The next works presented are caricatures of people looking at prints. They come from the first half of the 19th century, a time when political and social caricatures were popular in England and France, and they reflect this vogue (see nos. 5–10). After 1860, the emphasis in the works shown changes from satire to more straightforward depictions.

The 1880s saw a dramatic increase in interest in prints of all sorts; the passion continued, reaching its peak in the next decade, with France as the center of activity. The number of artists working in prints surged; publications on prints began to appear in earnest; numerous societies of printmakers and print amateurs were founded. Thanks, in part, to advances in color lithographic processes and more lenient French regulations about placement of notices, the poster catapulted into prominence. In tandem with the burst of enthusiasm for the graphic arts came a proliferation of prints about prints, documented here by a large number of works from the last two decades of the 19th century (nos. 13–45). Exhibition advertisements and other commissioned works promoting prints dominate this group.

[1]Walter Strauss, *The German Single-Leaf Woodcut 1550–1600* I (New York, 1975), p. 2.
[2]Georg Hirth, *Picture Book of the Graphic Arts 1500–1800* IV (Munich, 1882–90; reprint edition, 1972), no. 2000.

The promotional works continued into the early years of the 20th century, after which the print frenzy faded and the need for them declined. They have only appeared sporadically after that. In the past two decades, there has been another wave of interest in prints. However, since exhibition posters can now incorporate photographic reproductions of the art works on display, special scenes vaunting the works are not as necessary as they once were. Likewise, original prints are no longer practical as frontispieces for books on prints.

Another factor affecting prints about prints in this century has been abstract art. Scenes showing people looking at prints or making prints are inherently realistic, and thus have not suited the styles of many modern artists.

Although prints with a print theme have been less common in the 20th century than at the end of the previous one, they have continued throughout. In these works, portraits of printmakers play a greater role again, and portraits of printers appear. There are more scenes done simply as works of art. More American artists have used print themes than before. The prints selected reflect these changes (see nos. 46–70).

Certain general observations can be made about the group of prints chosen for exhibition, which apply also to the larger group of prints that have been done on the theme. The conventions for depicting prints deserve mention, for instance, and other features of the scenes invite comment.

Various standard methods are used for the depiction of prints. The convention for the face of a print is a dark rectangle bordered by crisp white margins. Within the rectangle, a scene may or may not be represented (see nos. 14 and 19). Lithographs are shown with their characteristic irregular image outline (no. 36). Many artists depict an unmounted print bending or rippling in exaggerated fashion, as if to make sure the outside viewer knows he is looking at a work of art on paper (no. 3). If the face of the print is not exposed, other details of a scene can be used to help convey its identity as a print. Portfolios, printmaking tools, or the lettering of an advertisement can, for instance, assist in this (nos. 26, 40).

It is common for artists to devote special attention to the subsidiary prints, giving them detailed images that complement the main scene in some way. In a gallery advertisement, the subordinate images help describe the works on sale. In a portrait of a printmaker, they demonstrate the style of his work. In a caricature, they aid the satire. Elsewhere, they perform other functions. However the subsidiary print is handled, it also serves as a reminder that the main work itself is a print, thus encouraging appreciation for it as a work of art. The scenes showing printmaking, rather than actual prints, contain a similar reminder.

There are no set conventions for the representation of printmaking.

Almost any stage of the complicated process can be represented, from the artist's first placement of a design on the plate (see no. 65) through the printer's final examination of the proof (no. 59). Furthermore, any of the graphic arts can be shown, with resulting differences in the equipment and techniques depicted. The emphasis is rarely on technical demonstrations (for an exception, see no. 67). Sometimes even mythological figures are depicted doing the printmaking (no. 22).

One noteworthy quality of the scenes that is a result of the print medium is their intimacy. Prints are small, and although some artists present elaborate tableaus, most prefer a scene concentrating on one or two figures. They put the figures up close, and provide the necessary background detail with great economy of means. Depicted prints, which are proportionately small, are often hand-held, increasing the impression of intimacy.

The entire group of prints about prints stands against a broader background of self-mirroring works in other art forms. In literature, there is the venerable device of the frame story, within which sits another story, and in music, there is the fugue, with its contrapuntal variations, in which the same theme can run both backward and forward. In painting, of course, many types of scenes incorporate paintings or references to the art of painting. The most common are representations of the artist in his studio. Velasquez' *Maids of Honor*, with its play of mirrors, is a familiar example that goes beyond being a simple record of a studio scene. Representations of painting collections are also frequent. An unusual instance of a painting showing paintings that is also an advertisement is Antoine Watteau's signboard of 1721 for the art dealer Gersaint.[1] The figures in this work help the advertising purpose, as do the print lovers in the print advertisements. Although one might not expect sculptures that include other sculptures, even these have been done.

As long as art exists, artists will continue to make works about art. As long as prints exist, printmakers will continue to make prints about prints. Because of the special fascination of such works, it will be interesting to see what form they take next.

[1]Julius Held and Donald Posner, *17th and 18th Century Art* (New York, 1971), fig. 315.

NOTE TO THE READER

EDITION
Where edition size is omitted, it is because this information is lacking both on the print itself and in the available literature. The majority of the prints were done before it became customary to record the size of an edition.

DIMENSIONS
The dimensions are stated height before width, and are taken from platemark to platemark, except for lithographs, where they record image size.

REFERENCES
The sources listed under this heading refer to the specific print illustrated, unless otherwise noted.

GENERAL BIBLIOGRAPHIC NOTE
In assembling the biographical data on the artists, standard reference works have been used extensively. Information obtained from such works has not been footnoted. Readers wishing to verify or supplement the material presented here are directed to the dictionaries listed below, which have been used most often. Other dictionaries have been helpful as well, particularly those for each nationality of artist. The *Fonds français* listings (see Abbreviations) contain valuable biographical sketches.

FREQUENTLY USED SOURCES

Bénézit, E. *Dictionnaire des peintres, sculpteurs, dessinateurs, et graveurs.* 10 vols. Paris, 1976.

Thieme, Ulrich and Becker, Felix. *Allgemeines Lexikon der bildenden Kunst.* 37 vols. Leipzig, 1907–1950.

Vollmer, Hans. *Allgemeines Lexikon der bildenden Künstler.* 6 vols. Leipzig, 1953–1962.

NOTE ON GRAPHIC TECHNIQUES

In spite of the presence of prints showing printmakers at work, this is not an exhibition about how prints are made. In the text of the catalogue, a basic knowledge of the media is assumed. Anyone not familiar with prints or wishing to know more about the technical aspect of prints is referred to the many fine explanations of printmaking processes that have been published elsewhere.

See, for example: John Buckland-Wright, *Etching and Engraving: techniques and the modern trend* (New York, 1973); Carl Zigrosser and Christa Gaehde, *A Guide to the Collecting and Care of Original Prints* (New York, 1965), pp. 37-82; Arthur M. Hind, *A History of Engraving and Etching* (3rd edition, New York, 1963), pp. 1-18; William Ivins, Jr., *How Prints Look* (New York, 1943).

AUTHENTICITY

Each entry describes an original work of graphic art, except for nos. 32, 34, and 37, which describe reproductions, as explained in the relevant entries.

ABBREVIATIONS

Béraldi = Henri Béraldi. *Les graveurs du XIXe siècle*. 12 vols. Paris, 1885–1892.

B. M. Satires = M. D. George. *Catalogue of Political and Personal Satires preserved in the Department of Prints and Drawings in the British Museum*. Vols. V–IX. London, 1935–1949.

Cate and Hitchings = Phillip Dennis Cate and Sinclair Hamilton Hitchings. *The Color Revolution; Color Lithography in France, 1890–1900*. New Brunswick, New Jersey, 1978.

Fonds français = Bibliothèque Nationale, Département des Estampes. *Inventaire du fonds français après 1800*. 14 vols. (incomplete). Paris, 1930–1967.

Le Blanc = Charles Le Blanc. *Manuel de l'amateur d'estampes*. 2 vols. Amsterdam, 1970–1971. Reprint of edition of Paris, 1854–1900.

Malhotra = Ruth Malhotra et al., *Das frühe Plakat in Europa und den U.S.A.* 2 vols. W. Berlin, 1973–1977.

CATALOGUE

No. 1
NICOLAS VERKOLJE. Dutch, 1673–1746.
After JEAN-MARC NATTIER. French, 1685–1766.
Portrait of Bernard Picart

Mezzotint
1715 after painting of 1709
332 x 241 mm.

References: Le Blanc, no. 6. Alfred von Wurzbach, *Niederländisches Künstler-Lexikon* (Amsterdam, 1906–11; reprint 1974), no. 7.

In this slightly theatrical portrait, the French printmaker Bernard Picart (1673–1733), dressed as a courtier, is seated in a library pointing to one of his own prints. His profession is underscored by his signature on the print and the inclusion of some of his working tools.

The image of the printmaker as gentleman-scholar is appropriate for Picart, who specialized in prints after paintings by famous artists of earlier generations, including Raphael and Poussin. Some of these artists are named on the spines of books in the background. Picart also did original prints of contemporary court life. These two aspects of his work are reflected in the accompanying epigram, "Neither cast off the old nor shun the things of today." Picart was eminent enough to have been painted in flattering fashion by the court painter Jean-Marc Nattier. In 1710, he moved from France to the Netherlands, presumably taking Nattier's portrait with him, for in 1715, in Amsterdam, the Dutch painter and engraver Verkolje engraved this version. This double authorship is scrupulously recorded in Latin in the bottom margin, following the pedigree "Bernard Picart, draftsman and engraver, son of Etienne Picart, known as the Roman."

While representations of prints within larger works frequently bear miniature signatures and have recognizable compositions, the one under Picart's pointing hand is unusual in that it includes a title as well. In tiny letters it designates a spurious antique work: "Carnelian (gem), known under the name Seal of Michelangelo, thought to have been engraved by Pyrgotoles of the time of Alexander." A 1709 Picart print of this subject was engraved after a drawing of Elisabeth (Sophie) Chéron, one of the first female members of the French Academy. Her name is included in the relevant entry in an early catalogue of his work.[1] The medallion itself is in the Bibliothèque Nationale in Paris, and is sometimes attributed to Pietro della Pescia, of the 16th century.[2]

[1]Bernard Picart, *Impostures Innocentes* (Amsterdam, 1734), p. 1.
[2]G. F. Hill, *Corpus of Italian Medals of the Renaissance* (London, 1930), p. 225.

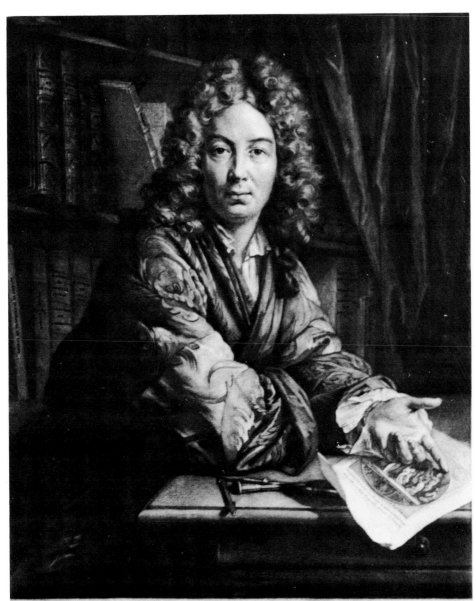

NEC VETERA ASPERNERE, NEC INVIDEAS HODIERNIS

BERNARDUS PICARTUS, Delineator & Sculptor, Stephani Picarti, cui Romano cognomen, Filius, natus Lutetiæ 11 Junii anni MDCLXXIII a I. Marc Nattier pictus anno MDCCIX. & a N. Verkolje L m. ære expressus Amstelodami MDCCXV.

No. 2
NICOLAS VERKOLJE. Dutch, 1673–1746.
After **ARNOLD HOUBRAKEN.** Dutch, 1660–1719.
Portrait of Jakob Moelart
Mezzotint
Ca.1727 after painting of ca.1710–19
261 x 196 mm.

References: Le Blanc, no. 5 (1).

 This 18th–century print is an early portrait of a print lover. The man shown here with part of his collection is Jakob Moelart (1649–ca.1727), an amateur painter who collected art. His interests are represented by paintings and a palette on his studio walls and by the display of prints in the foreground.

 The convention of representing prints as rippling sheets of paper with designs had already been established. The prints have the narrow margins characteristic of a time when paper was scarce and expensive. Moelart's prints were stored in an album, rather than loose in portfolios of the sort that became common later. Moelart himself is shown looking at the spectator, rather than at the print in his hands, for in the early 18th century it was considered paramount for the portraitist to capture the expression of the subject's eyes.

 Verkolje, who also engraved the portrait of Bernard Picart (no. 1), was working here from a painting by Arnold Houbraken, who is better known as an art historian, having written *De Groote Schouburgh*, an important document on the lives of 17th-century Dutch painters. Like Moelart, Houbraken was a citizen of Dordrecht.

 Although the inclusion of a skull as a *memento mori* was a common enough device in Dutch art of the period, it seems particularly appropriate in a work of art about art, for it turns the scene into a comment on illusion versus reality. The poem at the bottom is an elegy for Moelart.

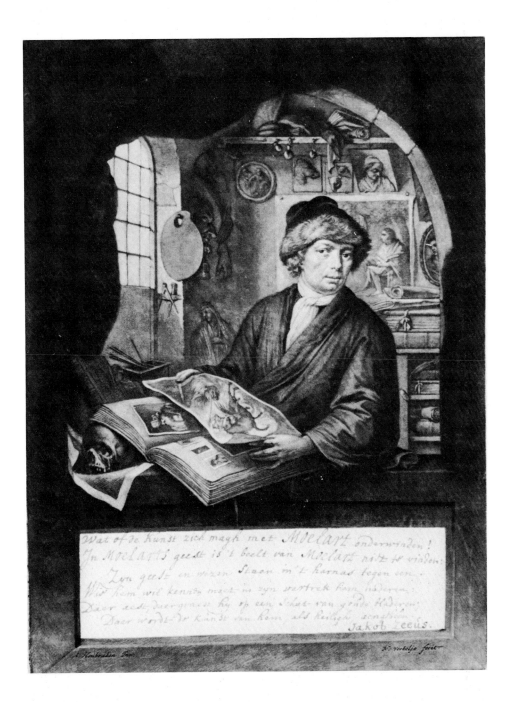

Wat of de kunst zich magh met Moelart onderwinden!
In Moelarts geest is 't beelt van Moelart niet te vinden:
 Zyn geest en wezen staen in 't harnas tegen een.
Wie hem wil kennen moet in zyn vertrek hem nadren;
Daer ziet, daer ziet men hy op een Schat van goede bladeren;
 Daer wordt de Kunst van hem, als heiligh, aengebeen.

 Jakob Zeeus.

A. Houbraken Pinx. C. vubelje fecit.

No. 3
PIETER TANJE. Dutch, 1706–1761.
After **J. M. QUINCKHARD.** Dutch, 1688–1772.
Portrait of Pieter Tanjé
Engraving with etching
1760
353 x 276 mm.

Reference: Le Blanc, no. 60.

The plate to which the engraver Tanjé points with his burin serves two purposes. First, along with the tools and the partially unfurled print before him, it identifies his profession. Second, it draws attention to the creative aspect of what he does. It is a blank surface on which he will cause images to appear. He is not shown actually at work because 18th-century portrait conventions forbade the apparent spontaneity of informal representations.

As in the portrait of Bernard Picart (no. 1), the costume and the setting convey a sense that the sitter is a man of upper class. A small sculpture and an array of books in the background show that the bewigged gentleman has cultivated taste. The print in the foreground depicts a subject drawn from classical mythology, in keeping with the grandeur of the scene as a whole.

In this variation on a self–portrait, the subject, Pieter Tanjé, did not design the likeness himself but only engraved it. J. M. Quinckhard may have been familiar with N. Verkolje's engraved portrait of Picart (no. 1), for at one point he had been Verkolje's student.

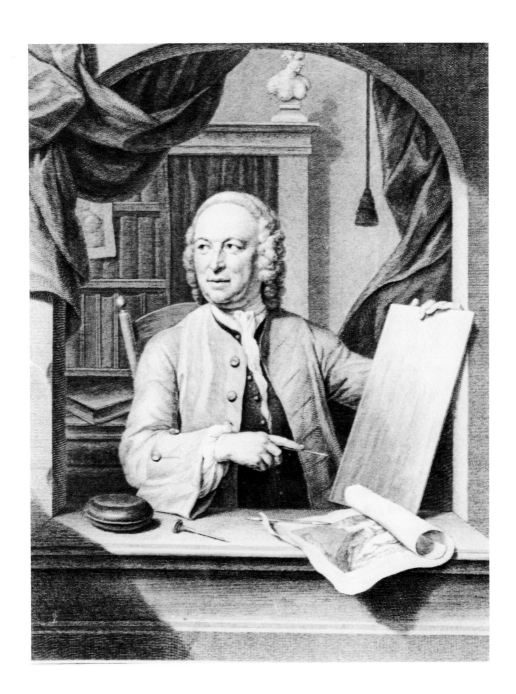

No. 4
JOHANN ELIAS HAID. German, 1739–1809.
After JACOB METTENLEITER. German, 1750–1825.
Portrait of Mettenleiter and Haid
Mezzotint
1784
306 x 372 mm.

Reference: Le Blanc, no. 46.

Although many prints of the 18th century and later result from the combined labors of painter and printmaker, it is slightly surprising to find a double portrait recording a partnership between two such men. This work suggests that the artist who rendered paintings into prints did not necessarily work separately from the painter. In this instance at least, it seems that there was an active collaboration between the two.

In the print the painter Mettenleiter and the engraver Haid are looking at prints by Haid after paintings by Mettenleiter. As the legend below indicates that their work is on sale at J. J. Haid and Son in Augsburg, this work must have been an advertisement, as well as a portrait. Mettenleiter sits on the left. He is identifiable as the younger of the two men, and his pose is more suitable to a self-portrait than the profile of his partner. The landscape print in the book and the figure study on the table suggest the range of the two men's works and interests, as do the paintings of various themes on the walls. It is typical of the conventions of the period that the two subjects portrayed show no involvement with the works.

This type of portrait was a "conversation piece," a group portrait in a social setting. It had been brought to a high point by the Dutch in the 17th century. The figures rarely speak but do gesture to one another, and the result is more informal than in the individual portraits. Both of these artists were German, but Mettenleiter had worked in the Netherlands. Dutch influence is apparent in both the portrait type and the composition. The chair in front repeats a device used by Vermeer to add naturalness to a scene. The text at the bottom is in French, indicating a desire to appeal to an international audience.

This work is a predecessor of the many 19th-century prints advertising other prints.

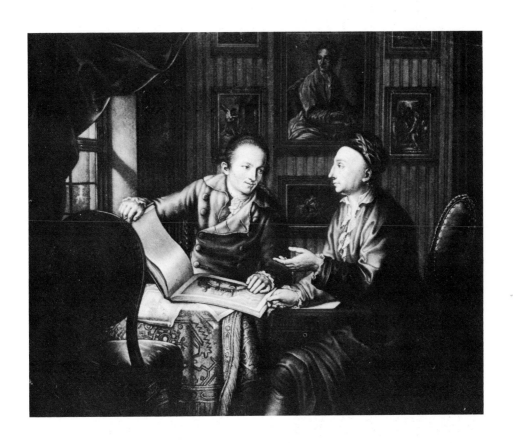

No. 5
ISAAC CRUIKSHANK. British, 1764–1810/11.
After **GEORGE M. WOODWARD.** British, 1760?–1809.
The Caricature Magazine or Hudibrastic Mirror
Frontispiece to vol. I
Etching, hand-colored
1807
245 x 347 mm.
Published by Thomas Tegg, London

Reference: *B.M. Satires*, no. 10889.

The Caricature Magazine was an early print-marketing venture, foreshadowing such later publications as *L'estampe originale*. When Thomas Tegg went into business as a printseller in 1807, he faced stiff competition from established London dealers. Drawing on his previous experience as a bookseller, he aimed at a larger market than the others, setting lower prices for individual prints and issuing the latest works in portfolio form under this title.[1] Five volumes were published, each containing approximately 90 to 100 prints.[2]

In George Woodward's design for a frontispiece to the first volume, a scowling matron and a paunchy gentleman each study prints of themselves that mirror their actual expressions. These figures and some miniature players below serve to draw attention to the caricatures on the ensuing pages. At the top, above a stage curtain, a theater audience watches. Each member of the crowd responds in a different way, yawning, snoozing, raising eyebrows, turning to neighbors, laughing, pouting, gasping, or politely smiling. Was Woodward mirroring his real-life audience?

Woodward's frontispieces and "tail-pieces" for this magazine are all caricatures about caricatures. Samuel Butler's satirical poem *Hudibras* inspired the subtitle *Hudibrastic Mirror*, and a 1725/26 Hogarth illustration to that poem,[3] which included a youthful Britannia looking at herself in a mirror, may have inspired the figures looking at prints in the frontispiece presented here. Woodward's drawings were etched by others, sometimes by artists who subsequently became more famous than he. In this instance, it was one of the Cruikshank family, which produced several well-loved caricaturists.[4]

[1]*B.M. Satires* VIII, p. xli.
[2]*B.M. Satires* VIII, p. 600.
[3]Joseph Burke and Colin Campbell, *Hogarth: The Complete Engravings* (London, 1968), no. 97.
[4]"Cruickshanks sculpt." could apply either to Isaac Cruikshank or to his son George, but since George was only fifteen at the time, the application to Isaac is preferable. The son was an apprentice and may have assisted his father, however. An attribution to the son in Albert M. Cohn's *George Cruikshank* (London, 1924), no. 110, is questioned by M.D. George in *B.M. Satires*, no. 10889.

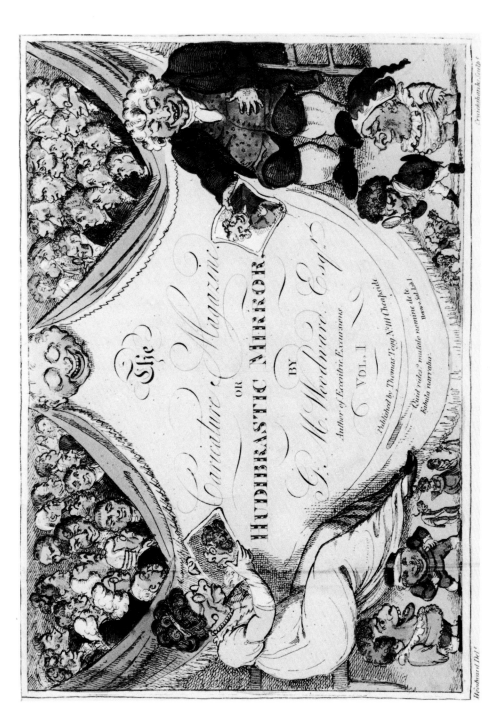

No. 6
THOMAS ROWLANDSON. British, 1757–1827.
After **GEORGE M. WOODWARD.** British, 1760?–1809.
The Genii of Caricature Bringing Fresh Supplies
Tail-piece to vol. III of *The Caricature Magazine*
Etching, hand-colored
1809
252 x 348 mm.
Published by Thomas Tegg, London

Reference: *B.M. Satires* VIII, p. xlii

Thomas Tegg must have been pleased with this print. A witty dramatization of Alexander Pope's words "Shoot folly as it flies" and a spirited advertisement for Tegg's print shop, it provides an apt finale for a volume of caricatures. The next volume of *The Caricature Magazine* is even announced in the shop window. Tegg and his subscribers must have been amused by his image in the doorway of the shop shooting down "folly": His is the only face not distorted by caricature.

The vision of a crowd of people clustered around a shop window and looking at prints was not entirely an advertiser's wishful thinking. This print was executed at a time when caricatures were extremely popular in London, and it is possible that curious onlookers did gather in front of print shops. A foreign visitor to England in 1802 reported that a trip to the caricature shops was part of the "daily round of a man of fashion."[1] At any rate this type of scene, with expected license taken in representing the enthusiasm of the crowd, did become part of the repertoire of artists advertising for print galleries. By contrast, the depiction of advertising messages being hauled in a net quickly disappeared in prints about prints. The messages here announce "portraits," "oddities," "whim," and so on.

Woodward also did this design, as is indicated on the plate, but no name is given for the etcher. Close analysis rules out the Cruikshank of no. 5 and several other possibilities. The style of Thomas Rowlandson, who started his association with Tegg in 1807, fits best, and he is known to have etched many of Woodward's designs,[2] including the frontispiece to vol. IV of *The Caricature Magazine*.[3] While it is sometimes difficult to identify an etcher when he is working from others' designs, Rowlandson's style is distinctive enough to be recognizable. This print and no. 7, both attributed to him on the basis of comparison to other works, reveal striking similarities in the free sketches in the windows and other details.

[1] *B.M. Satires* VIII, p. xli.
[2] For a list of his prints, see Joseph Grego, *Rowlandson the Caricaturist* II (New York, 1880), pp. 398-409.
[3] *B.M. Satires*, no. 11457.

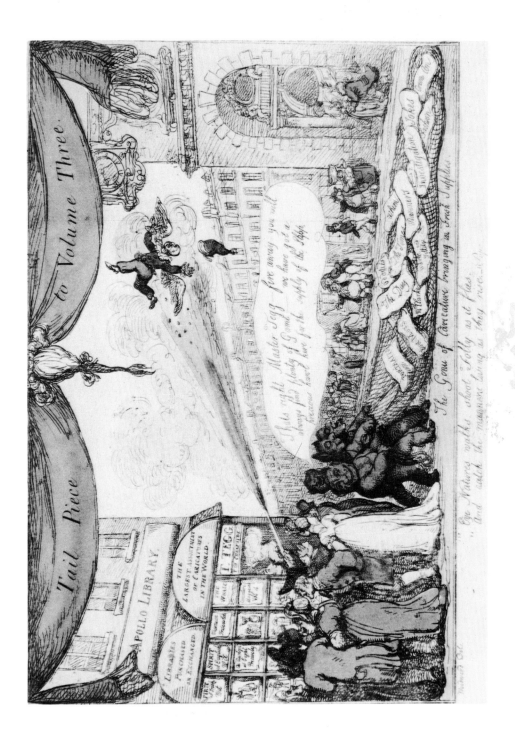

No. 7
THOMAS ROWLANDSON. British, 1757–1827.
After **JEAN-FRANÇOIS BOSIO.** French, 1727–1832.
Les musards de la rue du coq à Paris
Etching, hand-colored
Ca.1807–15, after engraving of 1802
278 x 390 mm.
Published by Thomas Tegg, London

Reference: Pierre-Louis Duchartre and René Saulnier, *L'imagerie parisienne* (Paris, 1944), p. 229 (for Bosio's version).

 This unsigned print provides an interesting challenge to the connoisseur. Although it has a French title and text, the name of the publisher Tegg on a sign at the left reveals an English connection. Furthermore, a placard in French mentioning the "Life and Death of the Tyrant Bonaparte" suggests a stroke of wry English humor, rather than a *bona fide* French creation. A French print of the same scene explains the puzzle: This print is an English adaptation of a known French print, with mischievous additions.

 Bosio's version was an advertisement for the printseller François Martinet (here corrupted to Marinet), showing an idle crowd amusing itself in the street before his shop. The two prints in the center, labeled "Suprême bon ton" (Supreme good conduct), were Bosio's way of drawing attention to his other caricatures of people of fashion and at the same time commenting facetiously on the decorum of the fore-ground figures. In the English version, the French dealer sells anti-Napoleonic prints and Tegg's monthly publications, as well as the caricatures previously advertised. It is a freely drawn, reversed hand copy of its model, spruced up with small additions, compositional improvements in the background, and more energetic draftsman-ship. This lively draftsmanship helps to identify the English artist as Rowlandson. Indeed, Rowlandson supplied Tegg with many anti-Napoleonic works.[1]

 [1]In August, 1980, I had an opportunity to show a reproduction of this print to Harriet Bligh of the Andrew Edmunds gallery in London, which owns some of the original left-over print stock of Thomas Tegg and Son. I wish to thank her for examining it with me. She shared my opinion, also attributing the print to Rowlandson.

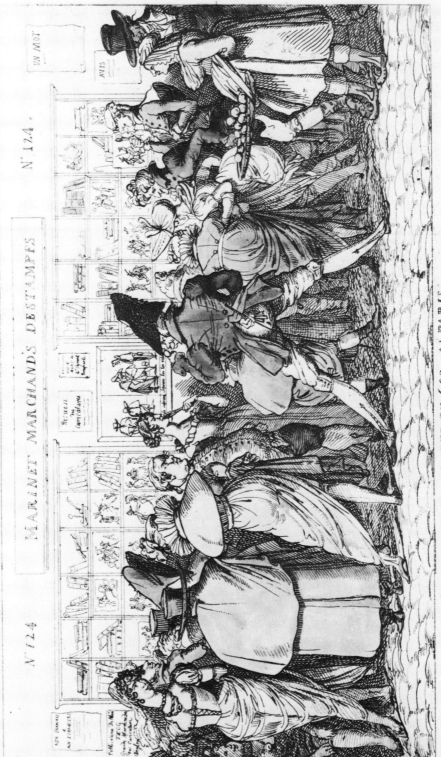

N° 124. MARINET MARCHANDS D'ESTAMPES. N° 124.

LES MUSARDS DE LA RUE DU COQ A PARIS.

No. 8

NICOLAS-TOUSSAINT CHARLET. French, 1792–1845.

"Tu vois Austerlitz au moment du tremblement!"

Lithograph
1827
195 x 148 mm.
Printed by Villain
Published by Gihaut frères, Paris

Reference: *Fonds français* IV, p. 336, no. 12.

Charlet's lithograph, a comment on the sad plight of veterans of the Napoleonic wars, includes prints used to supplement the narrative. An old soldier, whose days of glory are long past, has been reduced to selling his war stories for a few centimes, with the help of prints as a backdrop. He starts to describe, in an excited patter comparable to that of a modern sportscaster, the progress of the battle of Austerlitz. The cocky young soldier before him interrupts and recites Napoleon's famous words to his troops after that victory—"Soldiers, I am pleased with you"—as if to remind the veteran that his account is superfluous.

Although this message, conveyed by the text at the bottom, is topical and may no longer have the bite it once did, the image still appeals because of the poignant confrontation between generations and the incongruity between the soldiers and their setting.

Charlet sensed the enormous thirst for Napoleonic lore among the French public, and devoted most of his *oeuvre* of 1,200 lithographs to military subjects. They range from satirical prints like this one to dramatic battle scenes. His appreciative 19th-century audience included other artists. Delacroix admired his work,[1] and Géricault collaborated with him.[2]

[1]Kovler Gallery, *Forgotten Printmakers of the 19th Century* (Chicago, 1968), p. 64.
[2]François Courboin, *Histoire illustrée de la gravure en France* III (Paris, 1926), p. 180.

Ça vous Austerlitz, au moment du tremblement !

Voilà Rapp qui dit à l'Ancien : toute la boutique est couverte de l'Aigle se couvre de lauriers sur toute la ligne !

Soldats ! je suis content de vous, dit l'Autre !

Chez Gihaut frères, éditeurs.

No. 9

CHARLES JOSEPH TRAVIES. French, 1804–1859.
"Ces diables de députés! qué drôles de boules ils ont!"
Lithograph, hand-colored
1833
135 x 160 mm.
Printed by Benard, Paris

Reference: *Le charivari*, March 15, 1833.

A dapper little man, reading his newspaper over coffee, exclaims at a caricature of a politician: "Those devils of deputies! What funny heads they have!" His own head is equally comical and his hunched posture and near-sighted examination of the paper add to the humor.

In a more serious context, the subsidiary print can draw attention to the role of the main print as a work of art, preventing it from serving simply as an invisible window to another world. In a caricature, this device broadens the target of the satire to include whoever is looking on from outside. It is an ingenious method of turning an individual observation into a general statement, which may help explain why 19th-century caricaturists were fond of the device.

Traviès' print was published in the satirical daily *Le charivari*, the same paper that the man depicted is reading. He is laughing at a Traviès work that appeared in the January 31 issue of 1833, a few weeks before this print itself appeared.

The artist had studied at the Ecole des Beaux-Arts and had been a portrait painter before becoming a caricaturist and illustrator. Daumier, with whom he worked for *Le charivari*, occasionally borrowed images from this less known artist and adapted them to his own ends.[1] To the list of such instances can now be added an 1837 lithograph (Delteil 349) based on the print we see here.

The editor of *Le charivari*, Charles Philipon, was a shrewd businessman. In addition to newspaper caricatures, with printing on the back, he issued sets of the same works on heavier paper. These were for the collectors, and were sometimes hand-colored.[2] The print shown here is from such an edition.

[1]Charles Seymour, Jr., *Journal of the Walters Art Gallery* XI (1948), pp. 83-84; Jean Adhémar, *Honoré Daumier* (Paris, 1954), p. 127.

[2]I owe the information on Philipon's dual editions to the kindness of Miss Elizabeth Roth, Keeper of Prints at the New York Public Library.

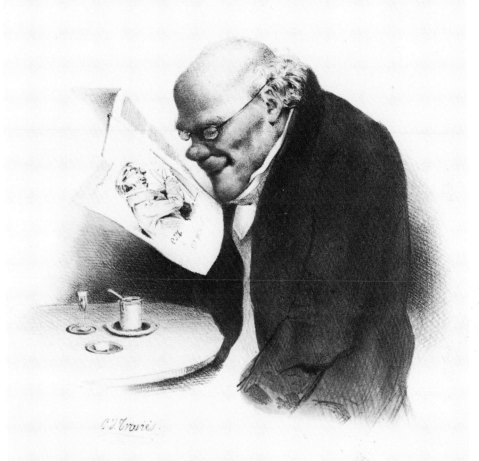

Ces diables de députés ! que drôles de boules ils ont.

Lith. Aubert, rue de l'Abbaye, N° 6. On s'abonne chez Aubert, galerie véro-dodat.

No. 10
HONORE DAUMIER. French, 1808–1879.
"Oursikoff!. . . trouvez-vous cela ressemblant?"
Lithograph
1854
2nd state of two
205 x 253 mm.
Printed by Destouches, Paris

Reference: *Le charivari*, June 21, 1854. Loys Delteil, *Daumier* (Paris, 1925–26; reprint New York, 1968–69), no. 2519.

Legend: "Oursikoff! Do you find this a good likeness?" "No, sire!" "That's good. I would have sent you to Siberia if you had recognized me. All these cheap shots of *Le charivari* do not prevent me from still being the handsomest man of my empire!" "Yes, sire!"

Honoré Daumier, whose name is almost synonymous with the art of caricature in the 19th century, shows his genius in this political cartoon made during the Crimean war. The victim is Tsar Nicolas I of Russia, who is examining an image of himself examining an image of himself and so on. The map of Turkey in the background underscores the connection with current events, specifically the Franco-British alliance to halt Russian expansion into Turkey.[1] Instead of criticizing the Tsar's policies, Daumier hit upon a personal weakness that all can understand: his vanity.

Daumier made the Tsar ridiculous by exaggerating the size of his torso and drawing an absurdly proportioned helmet. By contrast, the young officer Oursikoff is rather dashing, lending further irony to the exchange. The images of the tzar in the subsidiary *Le charivari* caricatures are identical to the main one.

Although Daumier could attack a foreign leader with impunity in wartime, he had to be more careful where he thrust his barbs at home. He had spent six months in jail after an 1834 caricature of King Louis-Philippe as a pear.[2] For most of his career, he worked for the daily *Le charivari*, which began publication in 1832. Beside producing more than 4,000 lithographs, he still found time to paint and sculpt.[3]

[1]A mock letter from the Tsar concerning the recall of his ambassador to Athens appears in the same issue of *Le charivari*.

[2]A. Hyatt Mayor, *Prints and People* (New York, 1971), 200, 661.

[3]Other prints by Daumier with subsidiary representations of prints include both this type, in which someone holds a caricature of himself, and scenes of art galleries, in which people turn up their noses at art they do not understand. He also did paintings of similar subjects. The themes were not new with Daumier, but his versions were particularly trenchant.

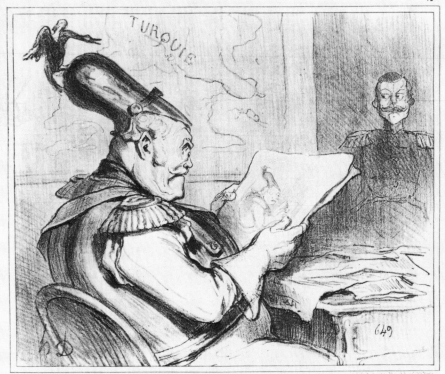

_____ Oursikoff!, trouvez-vous cela ressemblant ? _____ Non, Sire !......
_____ A la bonne heure je vous aurais envoyé en Sibérie si vous m'aviez reconnu toutes ces mauvaises charges du CHARIVARI n'empêchent pas que je ne sois toujours le plus bel homme de mon empire !
...? Oui Sire ! _____

No. 11
A. P. MARTIAL. French, 1828–1883.
Le siège de la societé des aquafortistes
Etching
1864
254 x 362 mm.
Published by Cadart & Luquet, Paris

Reference: Janine Bailly-Herzberg, *L'eau-forte de peintre au dix-neuvième siècle* (Paris, 1972), no. 124.

This scene of Paris in the 1860s is an advertisement for the medium of etching, for the noted art gallery of Cadart & Luquet, and for the Society of Etchers, which had its headquarters at the gallery. The aristocratic dress and bearing of the people looking at prints in the windows, as well as the ornate facade of the building, which is rendered in loving detail, underscore the prestige of the establishment.

The print foreshadows many later 19th-century gallery advertisements showing fashionably dressed people examining prints for sale. Earlier scenes of this sort had often been caricatures, but now they take on a more respectful tone.

The artist, A.P. Martial, was a member of the short-lived Society of Etchers (1862–1867), which was instrumental in the revival of etching that took place in mid-19th century France. In the first decades of the century etching had been over-shadowed by engraving, the severe line of which appealed to the followers of J.-L. David, and by the new medium of lithography.[1]

Martial's composition is artfully arranged to convey maximum information. The paintings and sculpture visible through the doorway show that Cadart & Luquet dealt in these media, as well as in the etchings prominently shown in the foreground. The building signs further specify the range of art on sale and give the address.

[1]Bailly-Herzberg, *op. cit.*, pp. 144-147 and p. xiii.

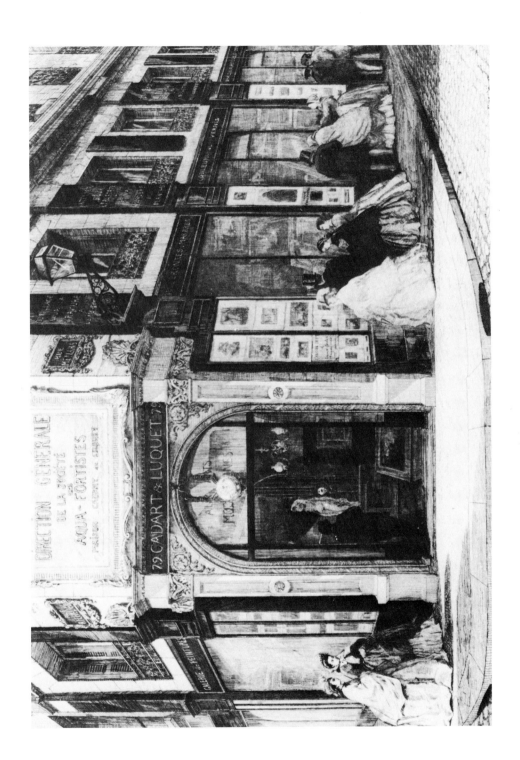

No. 12
FELICIEN ROPS. Belgian, 1833–1898.
La presse (Imprimerie en taille douce/F. Nys)
Etching
Before 1878
86 x 117 mm.

Reference: M. Exteens, *L'oeuvre gravé et lithographié de Félicien Rops* (Paris, 1928), no. 589 (state illustrated).

Like print no. 11, Félicien Rops' etching is an advertisement—but aimed at a different audience. An announcement for Rops' printer F. Nys of Brussels, it was designed to lure artists to use Nys' services as a printer of etchings and engravings and a teacher of etching. The light-hearted vision of a printing press operated by putti makes printmaking look like fun.

Although he is best known for his paintings, particularly those linked to the Symbolist style, Rops left a large graphic *oeuvre*. He produced many etchings and several posters. When he worked in Belgium, he took his etchings to Nys; when in France, he relied on the famous printer of etchings Auguste Delâtre (nos. 14, 19). He knew a great deal about etching techniques, as a letter he wrote on the subject to Delâtre demonstrates; it was printed as an appendix to Delâtre's treatise on etching.[1]

[1]Auguste Delâtre, *Eau-forte, pointe sèche et vernis mou* (Paris, 1887).

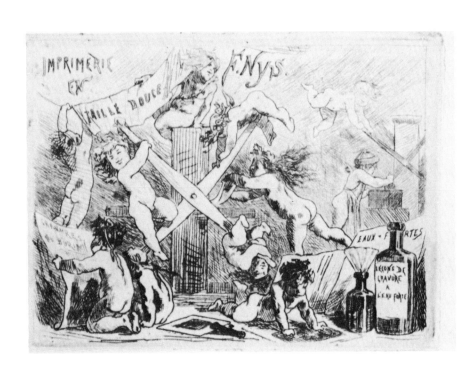

No. 13
HENRY SOMM. French, 1844–1907.
Chez l'imprimeur
Etching
1880s
Signed on the plate
49 x 79 mm.

 This whimsical scene represents the moment when actual etching takes place, that is, when acid attacks the lines of a design that the artist has previously scratched on a rosin-covered plate. Somm shows a woman standing over the acid tray, brushing air bubbles away from the plate with a feather. She is a conjurer of sorts, magically creating with each flick of the wrist another miniature clown or devil to inhabit the world of prints. Some of these sprites materialize in a cloud behind her, prancing in thin air above a floating stack of prints, while others loll about the studio observing her handiwork.

 Somm has taken the "miraculous" action of the acid on the etching plate as a basis for his own etching on the subject of etching and of artistic imagination. The woman could be a studio assistant whom he has observed at work or simply the product of his own imagining. The clowns that she brings forth find parallels in the prints of Chéret, who often depicted such clowns and even showed them in the process of being created (compare no. 17). Somm's intimate style distinguishes his work from that of Chéret, however.

 For another etching by Somm, see no. 14.

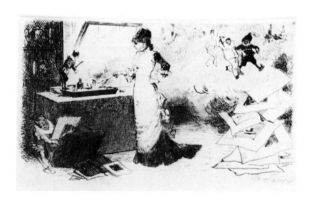

No. 14
HENRY SOMM. French, 1844–1907.
Imprimerie artistique/A. et Eugène Delâtre
Etching
Ca. 1887
Early state, without lettering
Signed in the plate
130 x 185 mm.

Reference: Janine Bailly-Herzberg, *L'eau-forte de peintre au dix-neuvième siècle* (Paris, 1972), ill. p. 7.

When Somm was commissioned to design an announcement for the printer Auguste Delâtre and his son Eugène, he planned the print in such a way that there could also be a special, unlettered edition for collectors. He left a large empty space for the lettering but framed that space with an image well enough balanced to stand on its own. The etching press and the infinity of prints flying in the wind are appropriate advertising symbols for a printing establishment, and the woman holding up one of the prints adds life to the scene. By firmly anchoring the composition in the lower left foreground and then allowing it to sweep into the farthest distance, Somm has injected drama into the design.

The announcement included on later states helps to date the print. It refers not only to the printing services and etching lessons at the Delâtre workshop but also to a treatise on etching techniques by Auguste Delâtre, which we know was published in 1887.[1] It is thus unlikely that the print was executed before 1887. Delâtre's illustration for Béraldi, from that same year (see no. 19), also incorporates the motif of prints blowing in the wind. It is difficult to say whether his or Somm's version came first. Somm and Delâtre clearly worked closely together, and Somm was one of the artists whom Delâtre chose for the six illustrations to his treatise.

Eugène Delâtre, who gradually took over his father's business, earned a reputation of his own for fine work. It was to him that the young Pablo Picasso was to turn for the printing of the etchings and drypoints of his famous *Saltimbanque* series of 1904–5, including *Le repas frugal*.

[1] Auguste Delâtre, *Eau-forte, pointe sèche, et vernis mou* (Paris, 1887).

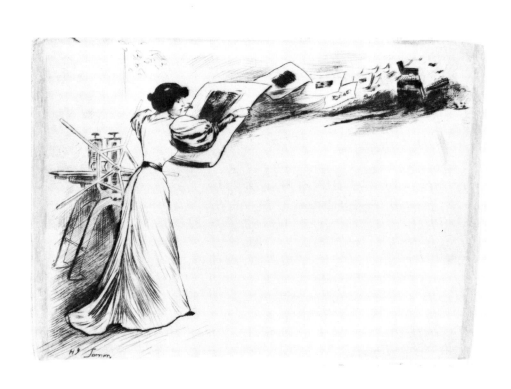

No. 15
FELIX BUHOT. French, 1847–1898.
Les salles d'estampes
Etching with engraving, aquatint, and drypoint
1887
Red owl signature stamp and brown FB stamp
Annotated "épreuve d'essai" (trial proof)
220 x 150 mm.

Reference: Gustave Bourcard and James Goodfriend, *Félix Buhot* (New York, 1979), no. 171, 2nd or 3rd state of 3.

Félix Buhot's etching of the outside of a print gallery combines a genre scene reminiscent of Rembrandt's work with a commercial announcement similar to those of Martial (no. 11) and Bottini (no. 29). The homage to Rembrandt, the greatest etcher of all, is embodied in the theme of two men conversing on the street and perhaps also in the dramatic handling of light and dark. Buhot adds the glimpse through the doorway, where figures can be seen leafing through portfolios of prints. Lettering over the doorway identifies the edition of etchings to which this print was the frontispiece.

Buhot was a prolific and talented printmaker whose etchings are currently enjoying a revival in popularity. He is best known for his urban and rural landscapes, which are often embellished by inventive marginal designs.

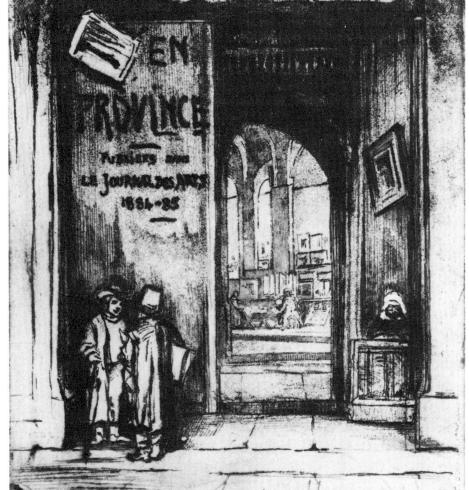

LES SALLES
D'ESTAMPES
EN PROVINCE
Publiées dans
LE JOURNAL DES ARTS
1884-85

FELIX BUHOT 1887

No. 16
NORBERT GOENEUTTE. French, 1854–1894.
L'amateur d'estampes
Etching
1880s
160 x 110 mm.

 Norbert Goeneutte was a minor artist, and his prints are scarcely masterpieces. This etching of a print lover, however, has the freshness of a quick sketch and stands up nicely on its own. The viewer is invited into a cozy interior with framed pictures on the wall, a sideboard, and a draped table holding a vase or teapot. A man, informally dressed in vest and shirtsleeves, leans over a rack of prints in the corner and rummages through what we assume is his own collection. He smokes a pipe. Goeneutte's loose line is perfect for this casual scene. We share in the enjoyment that the man seems to be deriving from his prints.

 The artist's graphic work consisted primarily of etchings and drypoints, although he did lithographs as well. He studied at the Ecole des Beaux-Arts and was one of the founders of the *Societé des peintres-graveurs français*.

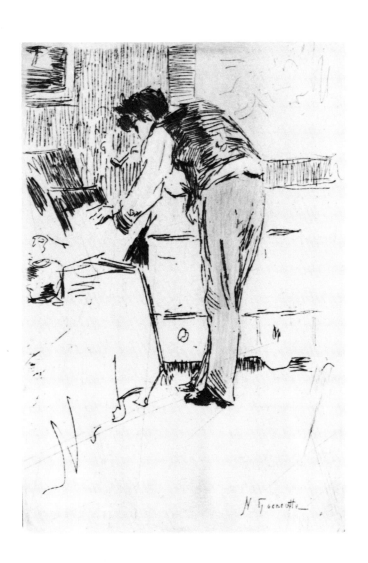

Nos. 17-24
FRONTISPIECES TO
Henri Béraldi, *Les graveurs de XIXe siècle*
12 vols. Paris, 1885-1892

These eight frontispieces to a 12-volume book provide an interesting sample of the way in which different artists can respond to the same commission. The work to which they belong, Béraldi's *Printmakers of the 19th Century*, consists of short, alphabetically arranged entries on the artists, with biographical data and lists of works. As the work dealt with contemporary artists, Béraldi and his publisher, Conquet, were able to arrange for some of the artists included to provide original prints as frontispieces. More prints were commissioned than could actually be used as frontispieces, and the rest appeared simply as illustrations. Each volume, therefore, had several prints in the style of frontispieces. Judging from the prints themselves, any theme could be used, as long as the artist included Béraldi's name and the title of the book. Some of the artists chose print-related subjects, and some did not. The eight prints selected here are among those that do have such subjects.

The dates given are the publication dates for the volumes in which they appear.

No. 17
JULES CHERET. French, 1836–1932.
Frontispiece to **Béraldi, *Les graveurs du XIXe siècle***
Lithograph printed in color
1886
212 x 140 mm.
Printed by Chaix (Chéret division), Paris

References: Béraldi IV. For Chéret, see Jane Abdy, *The French Poster* (New York, 1969), p. 14, and Cate and Hitchings, pp. 3-4, 12-14.

Something of the spirit of the carefree Chéret posters that once bedecked the streets of Paris is visible in this small print, in which a jovial barefoot woman personifies lithography and clowns tumble onto one of the prints that she has just created. The woman is shown dashing off a drawing on a lithographic stone set up on an easel. A press and supplies appropriate to her craft underscore for the viewer the nature of her activity.

That Jules Chéret's frontispiece for a book on printmakers was a print glorifying lithography is hardly a surprise. This branch of printmaking became popular and respectable in the last quarter of the 19th century because of his efforts more than those of any other artist. Chéret, the first great master of the poster, introduced new machinery crucial for printing large posters, and developed a style of design appropriate for those larger works. Thanks to him, younger artists like Pierre Bonnard and then Toulouse-Lautrec became interested in the possibilities of the poster.

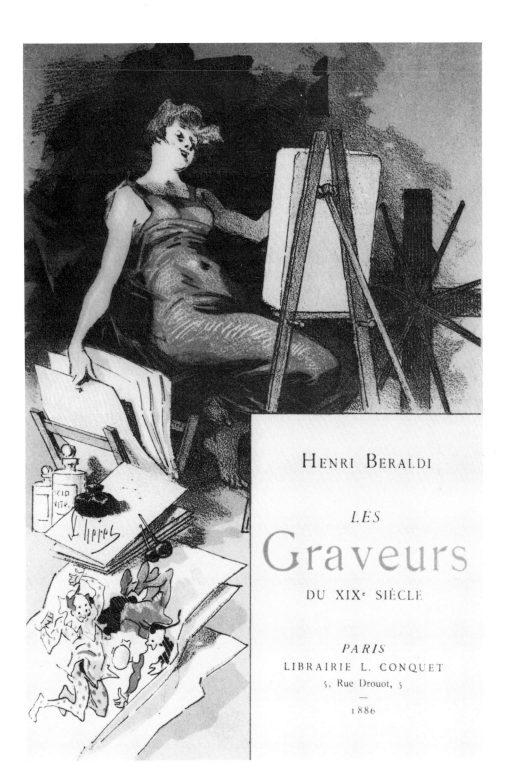

HENRI BERALDI

LES

Graveurs

DU XIXe SIÈCLE

PARIS
LIBRAIRIE L. CONQUET
5, Rue Drouot, 5
—
1886

No. 18
EUGENE-ANDRE CHAMPOLLION.French, 1848–1901.
After **HECTOR GIACOMELLI.**French, 1822–1904.
Frontispiece to **Béraldi**, *Les graveurs du XIXe siècle*
Etching
1886
175 x 110 mm.
Printed by Chardon & Sormani, Paris

Reference: Béraldi IV.

Instead of people looking at prints, this refreshing work shows sparrows engaged in the same activity. The birds, three of them, are poking their beaks at an array of prints scattered on the ground. Each examines a different print with beady eye. The prints are identifiable as such, following standard convention: They flutter and bend as sheets of paper do, and the images on them are surrounded by the neat margins associated more closely with prints than with other works of art on paper. The images themselves are landscapes and scenes of peasant life.

Giacomelli's birds provide an amusing counterpoint to the other prints in Béraldi's volumes and to the many other prints showing ladies and gentlemen of high society looking at prints. This artist was unusual in that he specialized in scenes of birds. E.-A. Champollion, who etched the print from Giacomelli's design, also created his own compositions.

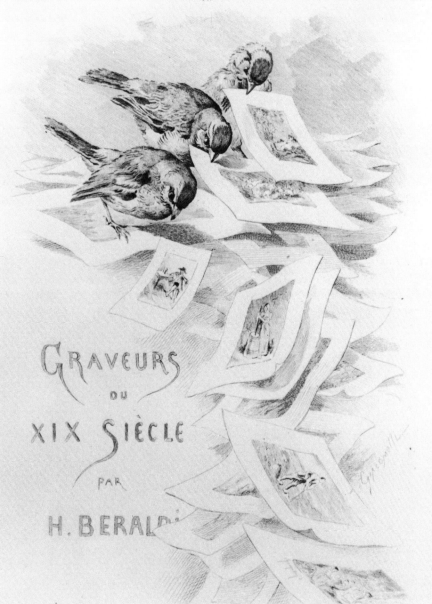

GRAVEURS

DU

XIX SIÈCLE

PAR

H. BERALDI

No. 19
AUGUSTE DELATRE. French, 1822–1907.
Frontispiece to **Béraldi**, *Les graveurs du XIXe siècle*
Etching
1886
210 x 148 mm.

Reference: Béraldi V.

Auguste Delâtre was both an etcher in his own right and a highly respected printer of other artists' etchings. He also gave lessons on etching technique and published a treatise on etching (see no. 14). The artists whose names appear on the prints of various styles floating down from his printing press were all people for whom he printed. They make an impressive list: Rops, Millet, Seymour Haden, Whistler, Tissot, Bracquemond, Delacroix, and others. Delâtre's complex composition is unusual because three of the subsidiary prints shown are not incorporated into the illusionistic setting but rather appear disproportionately large and pressed flat against the picture surface. This aspect may reflect his known interest in Japanese prints. Each of these three prints provides a "window" onto a landscape. Two have been adapted from his illustrated address cards; the other, designated "Aug. Delâtre del. & Sc.," must also have been taken from one of his previous etchings.

Delâtre's stature as a printer owed much to his reintroduction of "plate tone," a hazy background tone created through artful back-wiping of the inked plate. Rembrandt had known this technique, but it had subsequently been lost. Its revival by Delâtre played an important role in the revival of etching in the mid-19th century.[1] Several sojourns in London increased his reputation, raising him to a position of international influence. His pivotal role extended beyond the field of etching; it was his copy of Hokusai's *Mangwa* woodcuts, received with a shipment of Japanese porcelain, that is credited as having helped to spark European interest in Japanese prints. The artist Bracquemond obtained the book from Delâtre in about 1858 and showed it to an enthusiastic audience, which included Manet, Degas, and Whistler.[2]

[1]Janine Bailly-Herzberg, *L'eau-forte de peintre au dix-neuvième siècle*, (Paris, 1972), pp. 2-10.
[2]Hugh Honour, *Chinoiserie: The Vision of Cathay* (London, 1961), p. 210. Denys Sutton, *Nocturne: The Art of James McNeill Whistler* (London, 1963), p. 45.

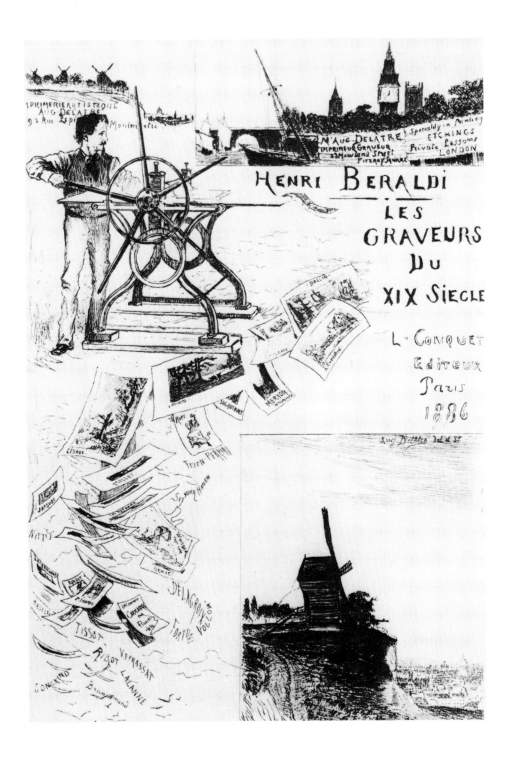

HENRI BERALDI

LES GRAVEURS DU XIX SIECLE

L. CONQUET Éditeur Paris 1886

No. 20
EUGENE GAUJEAN. French, 1850–1900.
After **DRANER** (pseudonym of **JULES RENARD**). Belgian (worked in France), born 1833.
Frontispiece to **Béraldi**, *Les graveurs du XIXe siècle*
Etching
1887
210 x 141 mm.
Printed by Chardon & Sormani, Paris

Reference: Béraldi VI.

In the 19th century, albums of plates illustrating the dress of various countries, occupations, and historical periods were very popular. Draner's frontispiece is a spoof of this kind of print. The two soldiers are looking at prints of men in various costumes and attitudes; they themselves might be two refugees from such prints, a haughty officer and a wide-eyed country bumpkin of lower rank.

Draner had an ulterior motive in drawing attention to the costume albums: to advertise his own studies of military types. He was not alone in using the Béraldi commission to tout his own work. Delâtre and Chéret did the same thing. Draner even managed to work in a spirited advertisement for the publisher, Conquet, whose name appears on the display in front of the soldiers, in a pun on conquest and acquisition.

The name Draner is an anagram for the artist's real name, Renard. He had arrived in Paris from Belgium in 1861 and had become active as a caricaturist for such newspapers as *Le charivari* and *Le monde illustré*. His style reflects the pervasive influence of his prolific predecessor as a military caricaturist, N.-T. Charlet (see no. 8). Draner conceived and drew the design, and Eugène Gaujean etched it.

No. 21
EUGENE GAUJEAN. French, 1850–1900.
After MAURICE LELOIR. French, 1853–1940.
Frontispiece to Béraldi, *Les graveurs du XIXe siècle*
Etching
1887
240 x 166 mm.

Reference: Béraldi VI.

This print is the only one in this show that attempts explicitly to honor more than one branch of printmaking. Leloir presents a gallery interior in the middle of which sits a fashionable dressed Parisienne gazing at a print in her hand. Loose prints, books, and portfolios are strewn about the cabinet top and on the floor. Tacked up on the wall are three prints announcing different media. Engraving, lithography, and etching are each celebrated by a pert young lady holding up a giant burin, a lithographic crayon in its adjustable holder, and an etching needle respectively. That more artists did not depict several media at once may partly reflect their fondness for certain media over others but surely also shows that they did not want to resort to devices such as this one of Leloir's to put their themes across.

Leloir's design typifies the style of an illustrator, and he did in fact do illustrations for Dumas' *The Three Musketeeers* and other novels. He was also a frequent exhibitor at the *Salon des aquarellistes français* in the 1880s. Eugène Gaujean, who executed a print from Draner's design (no. 20), etched this one as well.

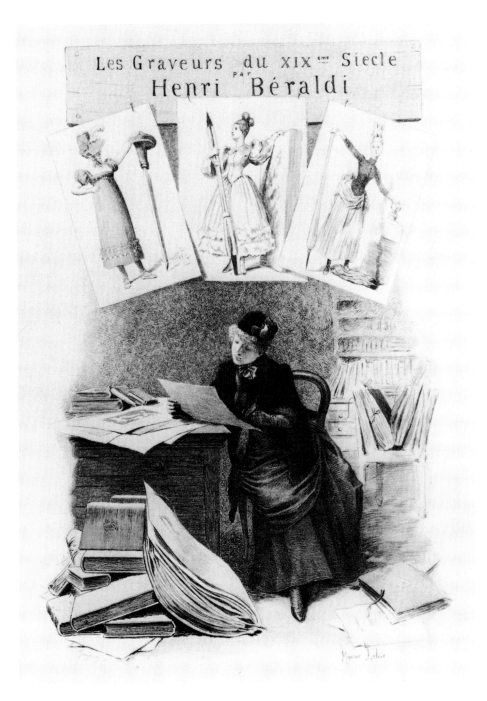

Les Graveurs du XIXme Siecle
par Henri Béraldi

No. 22
HENRI FANTIN-LATOUR. French, 1836–1904.
La lithographie
Frontispiece to **Béraldi**, *Les graveurs du XIXe siècle*
Lithograph
1887
180 x 110 mm.
Printed by A. Lemercier, Paris

References: Béraldi VI. Mme. Fantin-Latour, *Catalogue de l'oeuvre complet de Fantin-Latour* (Paris, 1911), no. 1326.

This print is one of several from the 1880s and 1890s in which a woman represents either the creative genius of lithography or a personification of that art. She is always dressed in a way that distinguishes her from the contemporary ladies of Paris. Sometimes she works hard at the task of creating a print; at other times her prints seem to have appeared miraculously, without any effort at all. Fantin-Latour's Lady of Lithography, in Greek attire, is one who has to labor to make a print. She draws on a lithographic stone propped upon a classicizing pedestal inscribed with the title of Béraldi's book. The classical references are particularly appropriate for the personification of an art that is named from the Greek for "stone writing," and they have the added virtue of lending an aura of tradition to this new art.

The intentionally blurred forms in the print, recalling the broken brushstrokes of Impressionist painting, mark it as an Impressionist work. Curiously, Fantin-Latour's painting tended in the direction of Realism, whereas his lithographs and pastels are more Impressionist. Here a manipulation of the grainy texture of the stone has enhanced the effect.

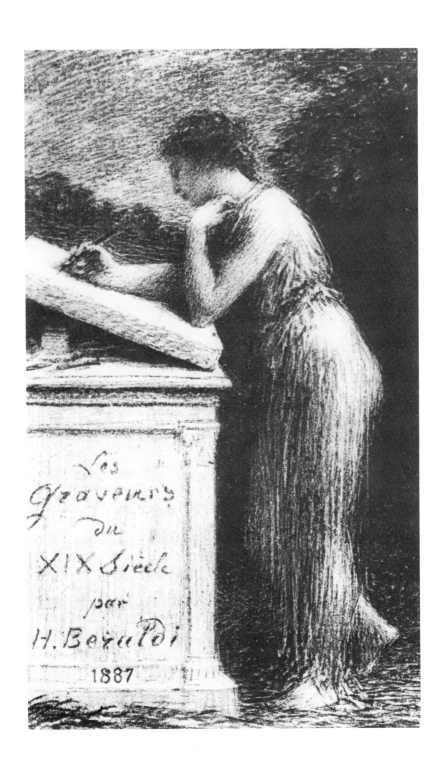

Les
Graveurs
du
XIX Siècle
par
H. Beraldi
1887

No. 23
AUGUSTE LEPERE. French, 1849–1918.
Frontispiece to **Béraldi**, *Les graveurs du XIXe siècle*
Wood engraving
1889
205 x 110 mm.

Reference: Béraldi IX.

For his frontispiece, Lepère did not have to fabricate an imaginary scene with prints floating from a printing press, prints examined by birds, or prints showing different branches of printmaking. As he specialized in renderings of the urban landscape, it was logical for him to think of a street scene related to prints. Why not show browsers at the stalls along the Seine, hunting bargains on a chilly autumn day? They seem to enjoy what they are doing enough to stay, despite the blustery weather.

By arranging his composition so that the riverbank runs vertically up the center of the print, instead of in panoramic view, Lepère was able both to suggest the locale and to focus on the two foreground figures, who give life to the scene. He used the wood-engraving technique to best advantage, making the lines of the men's coats swirl with the wind.

The picturesque bookstalls still stand along the Seine, but it is no longer possible to find high-quality original prints there, as it was a century ago.

For more on Lepère, see nos. 24 and 45. He was the son of a sculptor, and was himself also a painter.

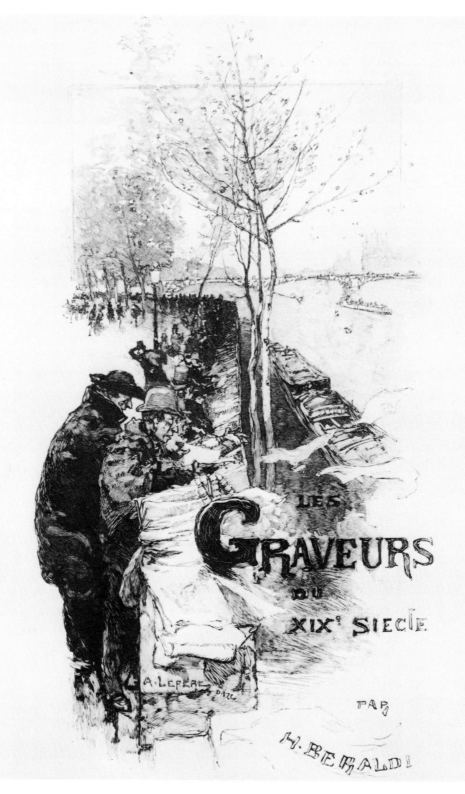

LES **GRAVEURS** DU XIXᵉ SIECLE.

PAR

H. BERALDI

No. 24
AUGUSTE LEPERE. French, 1849–1918.
After **EDMOND MORIN.** French, 1804–1882.
Frontispiece to **Béraldi,** *Les graveurs du XIXe siècle*
Wood engraving
1890
200 x 134 mm.

Reference: Béraldi X.

 In 19th-century Paris, fine prints were not something one had to go to a museum to see. Posters by artists of varying talents were an ever-present part of the outdoor life of the city, decorating kiosks and buildings of all sorts, as Edmond Morin's scene of a street cafe attests. Morin was skilled at catching the flavor of his times, and he built a successful career as a newspaper illustrator. In order that his work might be represented posthumously among the Béraldi illustrations, Auguste Lepère adapted one of his drawings into a wood-engraved frontispiece. Reproductive wood engravings, although on their way out because of advances in photography, were still an active industry in 1890. In spite of occasional works after other artists, Lepère was actually more interested in original wood engraving and did much to raise the level of that art, particularly in his role as one of the artistic directors of *L'image*, a periodical illustrated with wood engravings (see no. 41). For other examples of his work, see nos. 23 and 45.

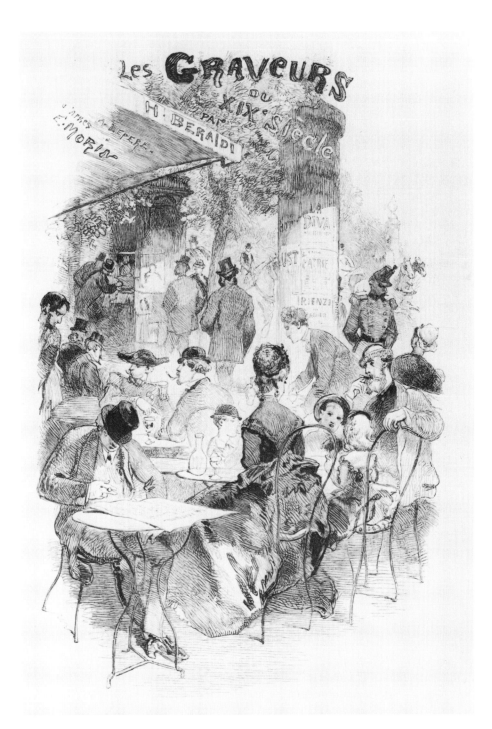

Les GRAVEURS DU XIXe Siècle PAR H. BÉRALDI

d'après A. LEPÈRE.

E. MORIN

Nos. 25–30
ADVERTISEMENTS FOR THE DEALER EDMOND SAGOT

In 1881 Edmond Sagot opened a shop in Paris dealing in books and in rare and contemporary prints.[1] He rapidly became the most influential print dealer of his day. Sagot was an enthusiastic supporter of posters, and in 1886, two years after the first poster exhibition in Paris, he became the first dealer to add illustrated posters to his inventory. His interest in them helped to increase their already growing popularity. In the 1890s, a period of intense activity in both prints and posters, his shop was a foçal point for collectors.

One of Sagot's methods of promoting his artists was to publish their prints and posters; to advertise his gallery, he commissioned works from them that had the additional purpose of attracting customers for them.

A selection of the advertisements using print-related themes is included here. Five of the six shown depict Sagot's customers perusing his print offerings. The customers stand outside the gallery, peering in, or browse at their leisure inside. Each artist used a slightly different approach, and the results are remarkable for their variety, given the similarity of theme.

No. 25
FELIX VALLOTTON. French (born Switzerland), 1865–1925.
Les amateurs d'estampes
Woodcut
1892
190 x 255 mm.
This impression stamped upper right with change of address to *rue de Chateaudun*.

References: Maxime Vallotton and Charles Goerg, *Félix Vallotton, Catalogue Raisonné* (Geneva, 1972), no. 107c. Malhotra II, no. 858.

Félix Vallotton hit upon a clever idea for representing Sagot's shop front without actually showing any prints. The prints in the gallery window are the unseen complement to his tableau, the focus on which the action converges. A Sagot customer could feel duly smug for knowing what it was that the crowd was rushing to see, and the curiosity of others would be aroused. Vallotton thus drew more attention to the prints by suppressing them than if he had shown them outright. The purpose of the work as a large address card for Sagot was more than adequately fulfilled. When the business later moved to the *rue de Chateaudun*, the print could easily be stamped with the new address.

The demands of the Sagot commission brought out Vallotton's considerable skill at composition. One's eye is led into the scene by means of poses leaning strongly to the right, and the motion is continued through compression of the main group of figures at the right side of the scene. By these means, the artist achieves the impression of a surge of movement towards the shop window. The Japanese-inspired device of cut-off figures further enhances the feeling of a rush of activity. The dynamic play of black, white and patterned forms against one another is typical of Vallotton's woodcut style and adds to the effectiveness of this print.

[1]For background information on Sagot, see Cate and Hitchings, pp. 12, 19-20.

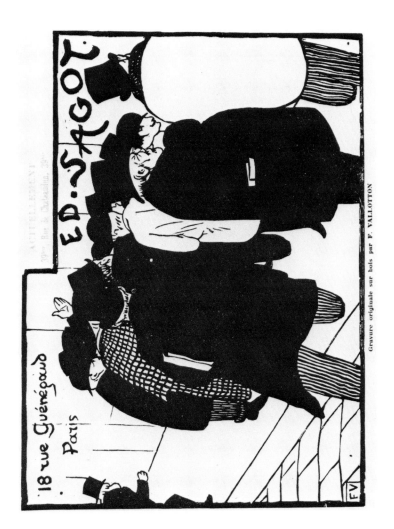

ED. SAGOT

ACTUELLEMENT
39... Rue de Châteaudun, 39...

18 rue Guénégaud
Paris

Gravure originale sur bois par F. VALLOTTON

FV

No. 26

ALEXANDRE LUNOIS. French, 1863–1916.

E. Sagot éditeurs/Rue Guénégaud 18

Lithograph

Ca. 1890–92

100 x 126 mm.

No. 27

ALEXANDRE LUNOIS. French, 1863–1916.

Ed. Sagot/39bis rue de Chateaudun

Lithograph printed in color

1894

156 x 215 mm.

Reference (for no. 27): Cate and Hitchings, fig. 18.

 Lunois did his first advertisement for Sagot's gallery while it was in the *rue Guénégaud* and a second one after it had moved to the *rue de Chateaudun*. In both, he used the familiar device of a woman holding up a print to examine it. The pose he chose is slightly unusual in that the woman sits facing the viewer. Other artists have tended to place her in such a way that the viewer can look over her shoulder at the print. In Lunois' works, it is the expression on the woman's face that enables the viewer to share her enjoyment.

 In the first version, Lunois set up a large portfolio next to her; its cover provided a handy surface for the necessary advertisement. Although the woman sits way off center, with a bright window behind her, the composition is nevertheless balanced by a dark section of wall flanking the window. In the second rendition of this theme, Lunois tried a more ambitious composition, adding another figure. It is very difficult to represent two people looking at the same hand-held print. Otto Fischer (no. 37) showed one standing and one seated figure, but Lunois, in an attempt to bring it off with two seated figures, has resorted to the awkward solution of cutting off the face of the gentleman. The overall effect is pleasing nonetheless. The lettering has been removed to the margin, so that no special accommodation has been necessary within the image; the presence of color also enhances the design.

 In both prints, Lunois built up his forms in broad patches on contrasting tones, exploiting the painterly possibilities of lithography. It is not surprising that he won prizes at the Paris salons in the 1880s, for paintings as well as for lithographs, and that most of his graphic work was in lithography, rather than in the more linear graphic media.

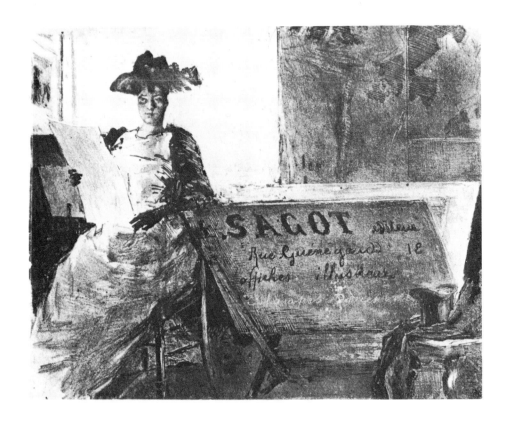

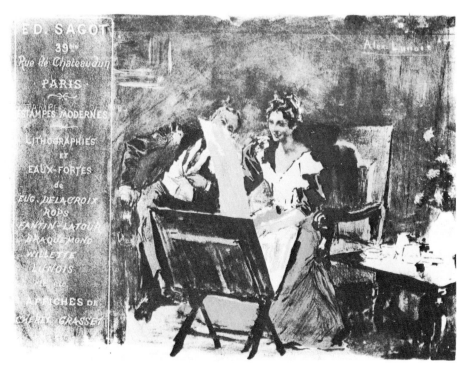

No. 28
G. MARIE. French, life dates unknown.
Edmond Sagot/Affiches, estampes/Etrennes aux dames/
Paris-Almanach
Lithograph printed in color
1897
855 x 610 mm.

Reference: Malhotra II, no. 562.

Marie's device for advertising prints was the invocation of a higher power in the form of a muse, or personification, of lithography. In this double poster for Sagot's posters and prints and for his *Paris-Almanach*, the muse appears on the left. She wears fanciful attire, not quite classical, not quite medieval, which suits the 1890s' sentimental vision of the past and contrasts tellingly with the up-to-date apparel of the real-life Parisienne who stands opposite her reading the *Almanach*. The other-worldly maiden on the left delivers her message for Sagot's gallery by holding up a poster of herself, which she has presumably just created, for she has a pen in hand.

Not much is known about the artist, but this and others of his posters show an interest in decorative pattern typical of Art Nouveau. It is recognizable in the wavy lines of the maiden's coiffure and in the arrangement of flowers in the vase by her side.

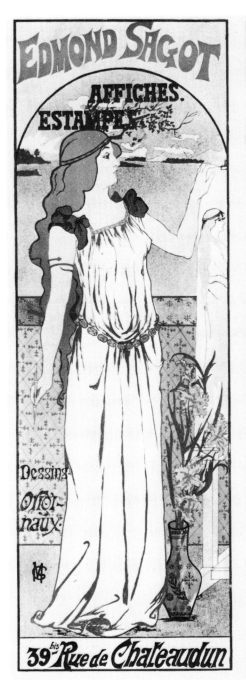

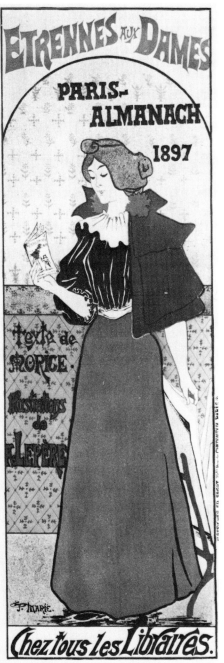

No. 29
GEORGE ALFRED BOTTINI. French, 1874–1907.
La galerie Sagot
Lithograph printed in color
1898
From the edition with the *remarque*
288 x 185 mm.

References: Victor Arwas, *Belle Epoque Posters and Graphics* (New York, 1978), ill. p. 6. Cate and Hitchings, fig. 28.

When storefronts are used in gallery advertisements, viewers peering at the vitrines invariably appear as well. They bring the storefronts to life, and they also lure other viewers to look at the works in the same window displays. In Bottini's Sagot poster, the prints spread out before the public are rendered in sufficient detail so that one can make out a boudoir scene, the head of a woman, and some land-scapes. The intent must have been to indicate the range of what was available inside the gallery.

Like the other works in the show that served commercial purposes, Bottini's print is engaging in its own right; the fact that it is an advertisement is secondary. Bottini created movement through the strong diagonal of the storefront, the lively sweep of the ladies' dresses, variations of pose, and alternation of colors. The quick assurance of his draftsmanship adds further interest. For this edition, the artist included a *remarque*, or marginal design, of a woman with a cat. Such designs were popular on prints of the late 19th century.

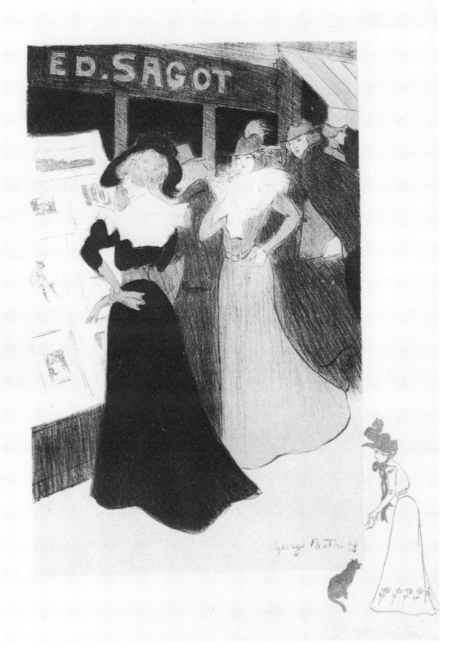

No. 30
PAUL HELLEU. French, 1859–1927.
Ed. Sagot/Estampes et affiches illustrées
Lithograph printed in color
Ca. 1898–1900
945 x 580 mm.
Printed by Chaix (Atelier Chéret), Paris

References: Malhotra II, no. 466. *The Poster* (Jan., 1901), ill. p. 35.

 By the time Helleu was commissioned to design an advertisement for Sagot, he had a traditional formula for print gallery posters to work against, and thus the challenge of finding a fresh interpretation. As Helleu specialized in portraits of society matrons, it was natural for him to want to retain the familiar motif of the fashionable lady looking at prints. What he did was to invent a new and more spirited pose for the lady. Rather than sitting or standing primly, the energetic woman in Helleu's poster sits sideways and grasps the back of her chair while she leans over to get a better view of the prints propped on an easel.

 Helleu's prints were immensely popular in his day. His slightly florid style, which evokes Boucher and other 18th-century masters, is recognizable in the exaggerated trailing skirt, in the delicate furniture, in the ornate typeface at the bottom, and in the pinkish brown ink, which simulates the effect of a pastel drawing.

ED. SAGOT

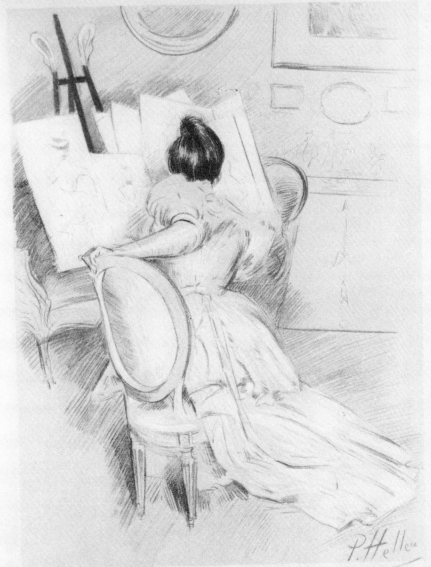

ESTAMPES & AFFICHES ILLUSTRÉES

39bis Rue de Châteaudun, Paris.

IMP. CHAIX (Ateliers Chéret) Rue Bergère 20 (1880) Toulouse

No. 31
HENRI DE TOULOUSE-LAUTREC. French, 1864–1901.
La lithographie, cover for 1st year of *L'estampe originale.*
Lithograph printed in color
1893
Edition of 100
Signed
565 x 640 mm.
Printed by Ancourt, Paris

References: Donna M. Stein and Donald H. Karshan, *L'estampe originale, A Catalogue Raisonné* (New York, 1970), no. 84.
Jean Adhémar, *Toulouse-Lautrec* (New York, 1965), no. 10.
Götz Adriani and Wolfgang Wittrock, *Toulouse-Lautrec* (Cologne, 1976), no. 10.
Loys Delteil, *H. de Toulouse-Lautrec* (Paris, 1920; reprint New York, 1969), no. 17.

The lively print market in the 1890s inspired a number of remarkable artistic ventures, not the least of which was a series of prints issued in quarterly portfolios from 1893 to 1895 under the title *L'estampe originale (The Original Print).* Seventy-four artists of major and minor stature—thirteen of whom are represented in this exhibition—contributed a total of ninety-five works in the various print media. Subscribers were able to build, by installment, print collections containing works by such well-known artists as Redon, Renoir, Signac, Whistler, and Toulouse-Lautrec. Lautrec created three lithographs for the project: a cover for the first year's installments, an individual print in the sixth installment, and a cover for the single installment of the final year.[1]

For the inaugural cover, he chose complementary scenes concerning the making and enjoyment of prints. The setting is the workshop of the Ancourt printing firm. When the cover is folded, each half of the composition stands on its own. On the front, Lautrec's favorite model of the time, the dancer Jane Avril, studies a proof straight from the press of the master printer Cotelle, who is shown at work on the back.[2]

The succinct yet fluid quality of the line reveals the hand of a deft draftsman. Lautrec had done his first poster for the Moulin Rouge in 1891, and in 1893 lithography was still a relatively new medium for him. He took advantage of the necessity for printing colors separately to turn the forms into flat color areas. This device also reflected his interest in decorative pattern, which became characteristic of Art Nouveau. The silhouette of Jane Avril's hat is a good example of that style.

[1]Stein and Karshan, *op. cit.*, p. 4 and nos. 84-86.
[2]*Ibid.*, p. 10.

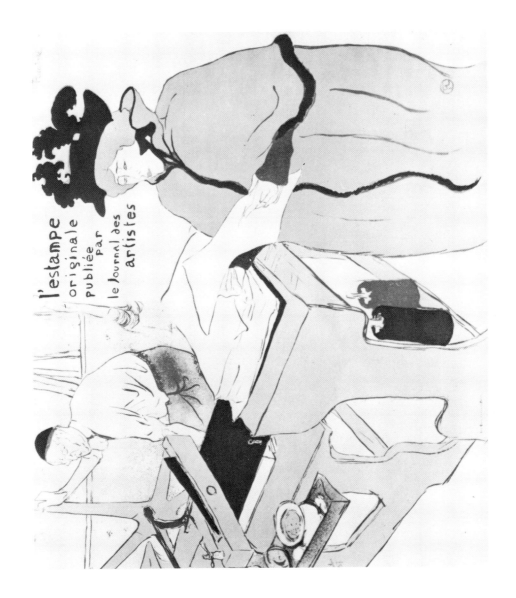

No. 32
FREDERIC-AUGUSTE CAZALS. French, 1865–1941.
7me exposition du salon des 100
Lithograph printed in color
1894
Reduced version, 1896, for *Les maîtres de l'affiche*
Original: 610 x 400 mm. Printed by Bourgerie, Paris.
This version: 320 x 200 mm. Printed by Chaix, Paris. Blind stamp of Imprimerie Chaix.

References: Roger Marx et al., *Masters of the Poster 1896–1900* (New York, 1977), pl. 15. Malhotra II, no. 139. Cate and Hitchings, fig. 44 and p. 31 (for *Salon des cent*).

This 1894 poster for the 7th exhibition of the *Salon des cent* provides us with information that might have surprised the artist. First, it is an early example of the now familiar advertising gimmick of employing a prominent person to lend credibility or prestige to a product: The two men shown visiting the exhibition are the poets Paul Verlaine and Jean Moréas. Second, the choice of poets as celebrities tells us something of their status and of the link between the literary and visual arts in their time. Third, the way the art works are hung informs us about exhibition techniques of an earlier generation.

In order to make both men recognizable and at the same time to show them looking at the exhibition, Cazals had to draw them in profile, and he had to render the wall before them on a diagonal. Note that Verlaine is shown hat in hand so that his bald pate can be visible.

The *Salon des cent*, or Salon of the 100, was a monthly exhibition organized by the editor of the review *La plume*, Léon Deschamps, and devoted to the display of paintings, sculpture, prints, and objects of decorative art by the one hundred artists who were members. The exhibition that Verlaine and Moréas are shown attending was devoted to prints.

Les maîtres de l'affiche (Masters of the Poster)

This publication of the late 1890s provided reduced versions of posters by subscription. The success of *L'estampe originale*, with its monthly installments of original prints, may have inspired it. As posters were popular, it is not surprising to find a similar venture for them. The awkward size of posters posed problems, however, and their advertising purpose made new commissions inappropriate. The publisher, Chaix, chose to distribute reductions of existing posters, along with occasional newly designed small prints by poster artists. Roger Marx served as editor. The 256 plates that appeared are fine lithographs, themselves in demand today. The masters included were of various nationalities, with emphasis on the French.

Beside Cazals' poster, illustrated here, three other works in this exhibition (nos. 34, 35, 37) are plates from the series.

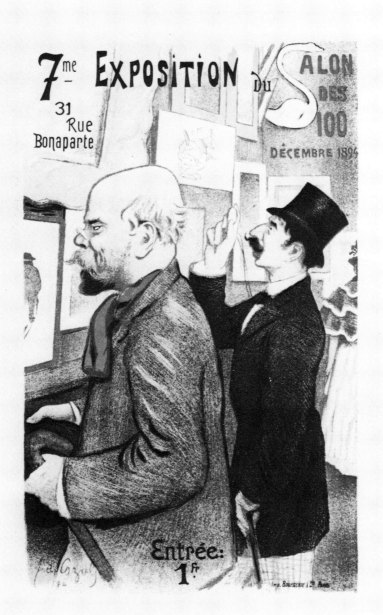

No. 33
FERNAND FAU. French, 1858–1917.
Salon des cent/14e exposition/31 rue Bonaparte
Lithograph printed in color
1895
Stamp F. F. within image
555 x 360 mm.

Reference: Malhotra II, no. 330.

Fernand Fau took his cue for this *Salon des cent* poster from F.-A. Cazals, who had prepared one for the same salon in the previous year (no. 32). Both artists represented the exhibition space at *31 rue Bonaparte* in similar succinct fashion, as one long wall on the left hung with works of art in a patchwork arrangement. The visitor whom Fau has selected to draw attention to the show is a lady from a fashion plate, clad in a multitiered cape and a grand plumed hat. She examines the prints carefully through a lorgnette and has her catalogue handy. We, the audience, cannot enjoy the works as much as she does, for the prints on the sharply receding wall are only very sketchily shown; we must derive vicarious pleasure instead from watching her. If we lived in Fau's time, perhaps we would be enticed to come to the Salon for a direct look at them.

In style Fau's poster is as up to date as the cape of the woman who stars in it. He flattened the space and played one decorative pattern off against the next in a way that was à la mode in 1895. The stylized wave pattern in the moss-green carpet may reflect the vogue for Japanese-inspired designs.

The plumed hat can be read as an "in joke" for those familiar with *La plume*, the review edited by Léon Deschamps, who was also the leading force behind the *Salon des cent*. The woman can thus be taken as a critic for *La plume*. She also subtly advertises Deschamps' poster-publishing concern, *Affiches artistiques de la plume*, which was located at the same address as the Salon. The feathers of the woman's hat are wittily juxtaposed against the address at the top of the poster.

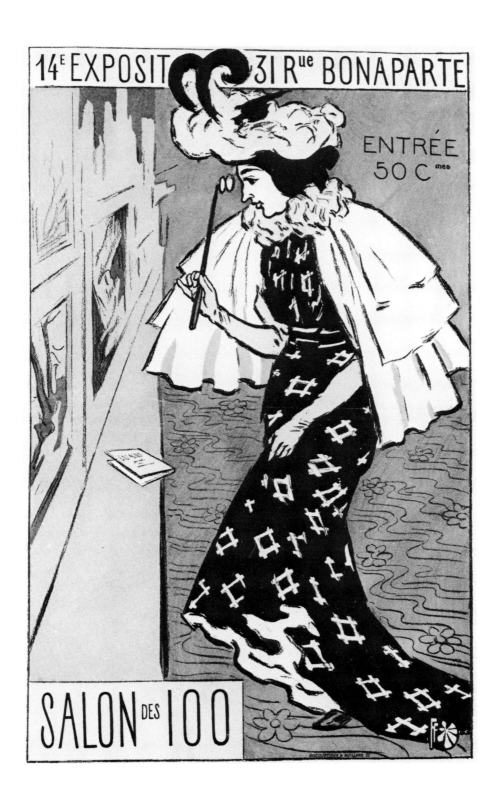

No. 34
FREDERIC HUGO D'ALESI. Rumanian (worked in France), 1849–1906.
Centenaire de la lithographie/Galerie Rapp
Lithograph printed in color
1895
Reduced version, 1897, for *Les maîtres de l'affiche*
Original: 1580 x 1150 mm. Printed by Courmont, Paris.
This version: 298 x 212 mm. Printed by Chaix, Paris.

References: Roger Marx et al., *Masters of the Poster 1896–1900* (New York, 1977),
pl. 66. Malhotra II, no. 16. *Fonds français* I, pp. 80-81 (for the artist).

In 1895 lithography was the subject of a centennial exhibition, for which Hugo d'Alési did a promotional poster. He chose a familiar theme, that of a smartly dressed lady looking at prints, but he drew more attention than usual to the prints themselves, giving enough detail so that we can identify the styles of the artists and can even make out some signatures. The lady is a customer at an outdoor print booth, and the prints she is admiring include a small lithograph by Charlet and a large poster by Chéret. The man in military costume in the former and the female figure in the latter are typical of the respective artists' works (compare nos. 8, 17). D'Alési obviously thought these two were the artists most likely to draw crowds to the centennial exhibition.

Hugo d'Alési was a painter and lithographer who specialized in advertisements for railway and ship lines. The stress in this poster on imparting information reveals the hand of one used to doing tourist publicity. The slightly sentimental quality also suits the vernacular of the period. The poster was well enough admired to be included in the *Maîtres de l'affiche* series in 1897 (see no. 32).

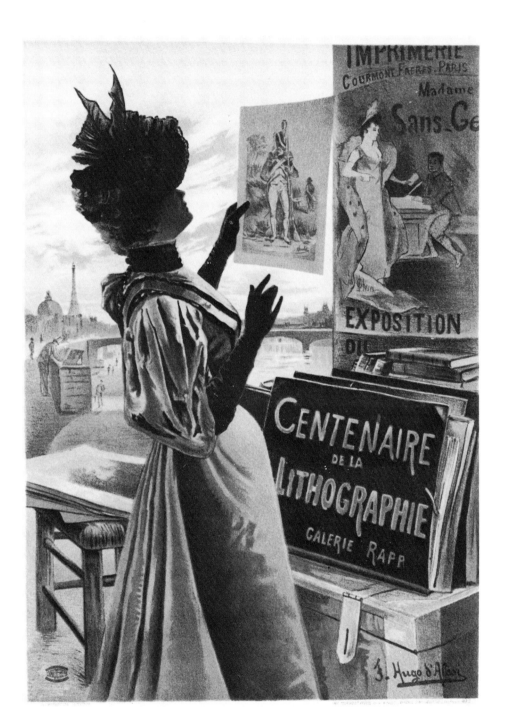

No. 35
JULES CHERET. French, 1836–1932.
Concert d'été
Lithograph
1896
233 x 188 mm.
Special plate for *Les maîtres de l'affiche*
Printed by Chaix, Paris.
Blind stamp of *Les maîtres de l'affiche*

Reference: Roger Marx et al., *Masters of the Poster 1896–1900* (New York, 1977), sp. pl. 1.

Along with small reproductions of posters, *Les maîtres de l'affiche* included bonus plates designed especially for the series. The subscribers thus could own original lithographs by major poster artists on the same conveniently small scale as the reduced works. *Concert d'été* was the first of these special plates, and it served as the cover of the first installment. To celebrate the series, Chéret chose a poster-related theme: A joyful clown invites the viewer to come look over his shoulder at posters, the top one of which is an announcement for a summer concert.

Although prints of people looking at prints often show the depicted prints turned so that the outside viewer can see the images on them, the person doing the looking usually appears oblivious to any real-world counterpart who may be looking on. Other graphic artists, of course, wanted to entice the public to come savor for themselves what the *dramatis personae* were enjoying, just as Chéret did. Chéret's interpretation stands out because the invitation is overt, the clown's glance drawing the viewer in. It is surprising that more printmakers did not use this device, which had been familiar in paintings at least since the Renaissance, as in paintings in which John the Baptist peers at the viewer while pointing out the figure of Christ.

For more on Chéret, the most prolific and influential poster artist of the 19th century, see no. 17. For other plates from *Les maîtres de l'affiche*, see nos. 32, 34, 37.

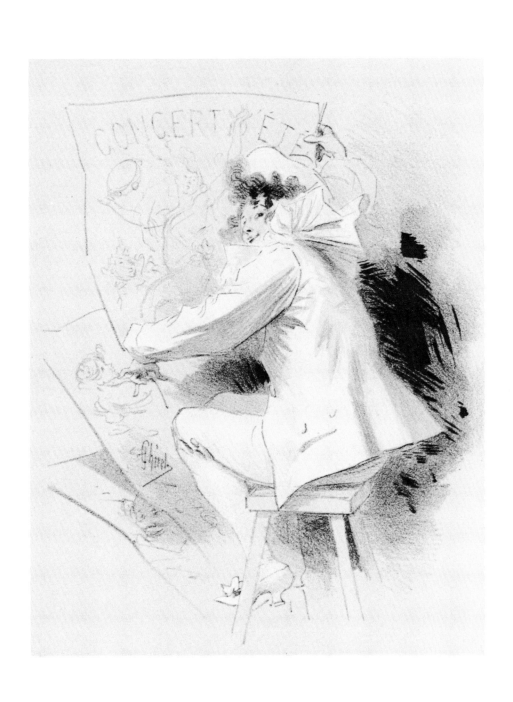

No. 36
PIERRE BONNARD. French, 1867–1947.
Exposition/Les peintres-graveurs/Galerie Vollard
Lithograph printed in color
1896
640 x 470 mm.
Printed by A. Clot, Paris.

Reference: C. Roger-Marx, *Bonnard lithographe* (Monte Carlo, 1952), no. 40.

Bonnard's poster for an exhibition of the *peintres-graveurs* in 1896 incorporates the familiar theme of a woman looking at a print, but in an innovative fashion. By the late 1890s it was possible to use this hackneyed subject as a point of departure for experiment with pattern. He let the woman's figure merge with the background, so that just the barest reference to her remains. Then he integrated the lettering into the design, making it part of an overall play of light on dark. He pushed the portfolio in the lower corner flat up against the picture surface, turning it into a simple geometric form. Were it not for the print that the woman is examining, shown in detail for the sake of the advertisement, and for touches of color that add a hint of modeling, the poster would approach abstract art.

The deliberate submergence of three-dimensional form in a patchwork of flat color zones is a reflection of Bonnard's painting style and is characteristic of Nabi artists.

As a poster designer, Bonnard was a great innovator. It had been an 1889 poster of his that had attracted the attention of Toulouse-Lautrec and inspired him to make posters himself.[1] The present poster was included by Vollard in the second of the *peintres-graveurs* albums, which he published in 1896–97.

[1]Antoine Terrasse, *Bonnard* (Geneva, 1964), p. 6.

No. 37
OTTO FISCHER. German, 1870–1947.
Kunst-Anstalt für Moderne Plakate/Wilhelm Hoffmann/Dresden
Lithograph printed in color
1896
Reduced version, 1898, for *Les maîtres de l'affiche.*
Original: 950 x 640 mm. Printed by Hoffmann, Dresden.
This version: 310 x 199 mm. Printed by Chaix, Paris. Blind stamp of *Les maîtres de l'affiche.*

Reference: Roger Marx et al., *Masters of the Poster 1896–1900* (New York, 1977), pl. 127.

In 1896, the first year of the Jugendstil, or German Art Nouveau style, Otto Fischer produced this striking poster of a man and a woman engrossed in looking at a large print. No setting is indicated, aside from the woman's chair, and the focus is entirely on the print within the print, which is turned slightly toward the viewer to reveal the image of two girls in a landscape framed by a tree branch.

The poster is an advertisement for a printing house, Wilhelm Hoffmann's Studio for Modern Posters in Dresden. It may have been for that reason that the artist dispensed with the gallery setting so frequent in French posters of people looking at prints, with which he was obviously familiar. The contrast in style between the poster itself and the subordinate image is noteworthy: The former relies on bold colors and flat planes, the latter on more intricate detail. Clearly, artists with many diverse styles were encouraged to bring their works to Hoffmann for printing.

For discussions of *Les maîtres de l'affiche,* see nos. 32, 35.

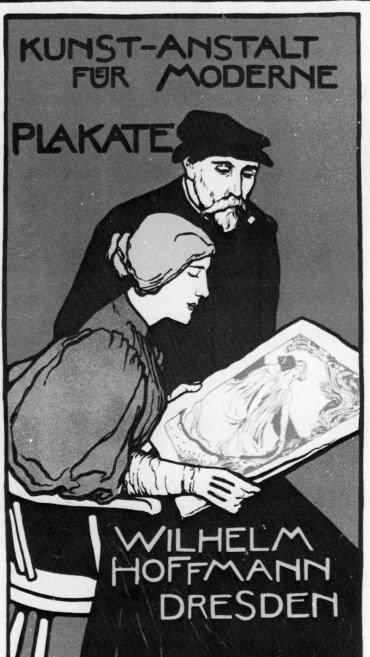

No. 38
ARMAND RASSENFOSSE. Belgian, 1862–1934.
Les affiches étrangères illustrées
Lithograph printed in color
1896
Cover for book of same title published by G. Boudet in 1897, with chapters by Meier-Graefe, Pennell, and others.
412 x 568 mm.
Printed by Chaix (Ateliers J. Chéret), Paris

Reference: Y. Oostens-Wittamer, *La Belle Epoque: Belgian Posters* (New York, 1970), no. 109.

 A poster fan in the 1890s—and there were many—could see examples all around him in the streets, could attend exhibitions, could purchase posters for his own collection, and could even subscribe to a series issued in easily stored small versions (*Les maîtres de l'affiche*). He could also build a library of books about posters. The jackets of such books were, of course, designed by poster makers. For a book on foreign posters published by Boudet in Paris in 1897, the jacket artist was, appropriately enough, the Belgian Armand Rassenfosse, a painter, poster artist, and book illustrator who had been a student of Félicien Rops.

 For his primary image, Rassenfosse borrowed a theme from exhibition posters, the fashionable dressed lady looking through a portfolio of prints. On the wall behind her and on the back section of the cover are montages of Belgian, English, American, and Japanese posters, rectangles of varying size pushed up flat against the picture plane. This device may have been derived from Japanese art via Manet and Whistler. Delâtre (no. 19) had also used it. Rassenfosse's entire design is set against a background of bright yellow, a color capturing the festive spirit of many of the posters of the period. One of the posters shown is his own *Huile russe*. The logo on the spine of the book incorporates a nude personification of lithography drawing on a lithographic stone.

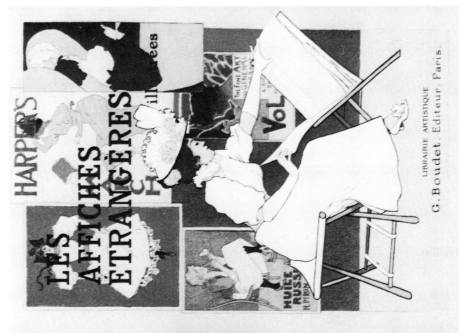

LES
AFFICHES
ÉTRANGÈRES
illustrées

PARIS
G. BOUDET
Éditeur
1897

LIBRAIRIE ARTISTIQUE
G. Boudet. Editeur. Paris.

No. 39
ANDREW KAY WOMRATH. American, born 1869.
XXVe exposition/Salon des cent
Lithograph printed in color
1897
460 x 340 mm.

Reference: Malhotra II, no. 895.

In order to advertise both the prints and the ceramics on view in the 15th exhibition of the *Salon des cent*, the American artist who designed this poster showed a man and a woman seated at a table, the woman casually studying three small prints, the man lovingly handling a small vase. Except for a house plant, no setting is indicated, but the dress and relaxed poses suggest that these people are at home, not in a gallery. Aside from the bold colors and the clean lines of the design, the appeal of the poster lies in this very informality and the sense that the people are comfortable with works of art. This fresh approach surely attracted visitors to come enjoy the works at the Salon.

A. K. Womrath had studied at the Art Students League in New York, then in Paris, under Grasset and Merson, and also in London. The style of this lithograph reflects his interest in wood engraving, apparent especially in the passages with white lines against dark, flat forms. Womrath was also a painter and illustrator.

For other posters for the *Salon des cent*, see nos. 32 and 33.

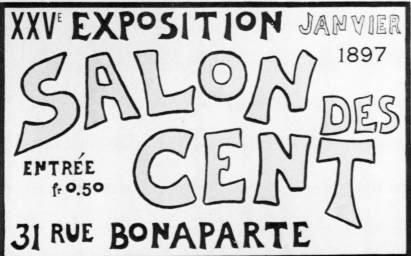

XXVᵉ EXPOSITION JANVIER 1897

SALON DES CENT

ENTRÉE fr 0.50

31 RUE BONAPARTE

No. 40
MARCEL LENOIR (Jules Oury, known as Marcel Lenoir). French, 1872–1931.
Affiches/Estampes/Lithographies/Arnould/7 rue Racine
Lithograph printed in color
Ca. 1895–1900
584 x 373 mm.

Marcel Lenoir's version of the muse or personification of lithography has her eyes shut, as if she were deep in thought. The inference is that great works of art are taking shape, works that the viewer will be able to find at the Arnould gallery.

The artist has conveyed the identity of this figure, first of all, by dressing her in a theatrical-looking costume, rather than in street clothes, and then by having her hold a lithographic crayon and a print; the latter is recognizable by the announcement "posters, prints, lithographs." This Art Nouveau work is distinguished by the artist's sensitive choice of colors and by his stylized, even whimsical treatment of the hair, the costume, and the lettering.

The gallery that commissioned the advertisement sold posters, not just traditional prints. Such evidence serves as a reminder that color lithographic posters were avidly collected during the heyday of their production, at the turn of the 20th century. It is thanks to the enthusiasm of collectors that so many of them have survived.

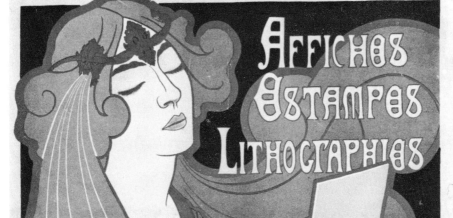

No. 41
M. P. VERNEUIL. French, 1869–1942.
Executed by **G. DUPRE, DETE,** and **LABAT.**
L'image, cover for 5th issue
Wood engraving, printed in color
1897
295 x 220 mm.

In planning this work, with its sinuous Art Nouveau plant tendrils echoing the graceful posture of the seated woman, Verneuil seems to have been acutely sensitive to the technical subtleties of wood engraving. An artist using this medium plows the lines of the design fluidly with a graver rather than chipping them out in more angular fashion with a knife, as in a woodcut. In Verneuil's cover, such details as the sweep of the woman's hair and of the plant forms are so well integrated into the overall conception that it is difficult to believe that more than one hand was involved. Yet the credits on the back of the cover tell us that it was composed by Verneuil and engraved by G. Dupré, Dété, and Labat. Verneuil presumably supervised the execution and had the power to reject interpretations that did not meet with his approval.

The purpose of the woman looking at a print was to advertise the wood engravings with which *L'image* was illustrated. After photographic illustrations became economical to produce, starting in the 1870s and 1880s, wood engraving, gradually freed from reproductive use, gained in popularity with artist-print-makers. That the sponsors of this artistic and literary review of the late 1890s were admirers of this medium reflects its new status. Even here, however, wood engravings after paintings illustrated articles on a painter's work, and the covers were the result of collaborative efforts.

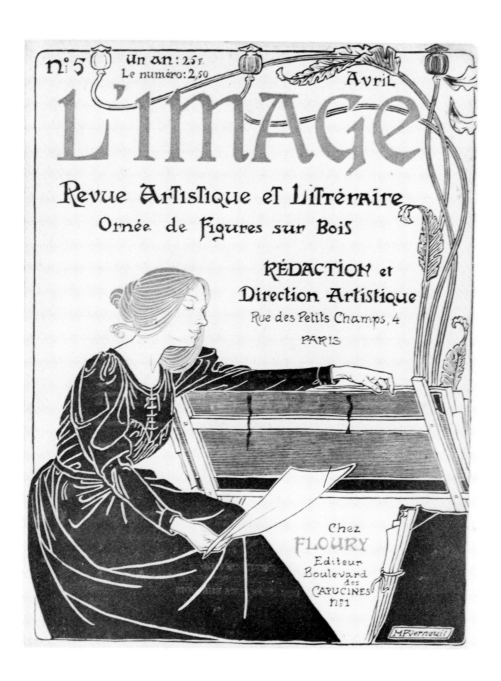

No. 42
THEO VAN RYSSELBERGHE. Belgian, 1862–1926.
N. Lembrée

Lithograph printed in color
1897
688 x 510 mm.
Printed by Ve Monnom, Brussels

References: Y. Oostens-Wittamer, *La Belle Epoque: Belgian Posters* (New York, 1970), no. 135. Malhotra II, no. 1128.

The Belgian van Rysselberghe apparently took a careful look at French works with a print theme as he set out to design this poster for a Brussels gallery selling 18th-century prints. The print-loving lady is a reprise of Jane Avril, in feathered hat and high-collared cape, from Toulouse-Lautrec's inaugural cover for *L'estampe originale* (see no. 31).[1] Other aspects may reflect one of Alexandre Lunois' advertisements for Sagot's gallery (see no. 26): van Rysselberghe used a portfolio cover for a sign, as Lunois had done, and played his figure off against a background similarly divided between window and wall. His modifications included turning the woman so that the images are visible on the prints she studies.

The Lembrée gallery boasted a telephone, prominently displayed at the left. Telephones were so new that the purpose of the number might not have been clear had the artist not put it on the appliance itself.

In style, the broad areas of uniform color again reflect the Lautrec cover for *L'estampe originale*. Van Rysselberghe was himself a contributor to that publication, having in 1894 provided an etching of a fishing fleet for the seventh album.[2]

[1]The parallel between these two works has previously been noted by Götz Adriani and Wolfgang Wittrock, *Toulouse-Lautrec* (Cologne, 1976), p. 58.
[2]Donna M. Stein and Donald H. Karshan, *L'estampe originale, A Catalogue Raisonné* (New York, 1970), no. 77.

Nº 1384

ESTAM
PES &
ENCADRE
MENTS
D'ART

GRAVURES DU XVIIIᵐᵉ S.

N·LEMBRÉE AVENUE LOUISE ·17·
BRUXELLES

No. 43
HENRI DE TOULOUSE-LAUTREC. French, 1864–1901.
Le bon graveur—Adolphe Albert
Lithograph
1898
2nd state of two
Edition of 100
Signed in pencil lower left
Red T-L signature stamp
344 x 245 mm.

References: Jean Adhémar, *Toulouse-Lautrec* (New York, 1965), no. 301. Götz Adriani and Wolfgang Wittrock, *Toulouse-Lautrec* (Cologne, 1976), no. 312. Loys Delteil, *H. de Toulouse-Lautrec* (Paris, 1920; reprint New York, 1969), no. 273.

Toulouse-Lautrec's portrait of his friend "the good printmaker" Adolphe Albert is an adaptation of a Rembrandt etching of 1648, a self-portrait of the artist at work.[1] Borrowing from Rembrandt was a way of paying a compliment to Albert, who had been a fellow student of Lautrec at the atelier of Fernand Cormon in 1883.[2] Lautrec posed Albert with a hat on, next to a window, just as Rembrandt had shown himself, but he turned the figure slightly and changed the vantagepoint.

Lautrec's sketchy style here is as characteristic of his graphic work as is the flatter, more decorative style associated with his famous posters. It is an index of his versatility as an artist that he continued to experiment with different modes of graphic expression.

[1]Adriani and Wittrock, *op. cit.*, ill. p. 214.
[2]Gerstle Mack, *Toulouse-Lautrec* (New York, 1952), p. 56.

No. 44

FERNAND-LOUIS GOTTLOB. French, 1873–1935.

2e exposition des peintres-lithographes/Salle du Figaro

Lithograph printed in color
1899
1125 x 740 mm.
Printed by Lemercier, Paris

References: Roger Marx et al., *Masters of the Poster 1896–1900* (New York, 1977), pl. 219. Malhotra II, no. 392.

Perhaps it is the handling of silhouettes that gives this poster of a woman print fancier its appeal. The scene is a gallery interior. Gottlob has placed the woman in front of a large window, and through dramatic back-lighting has emphasized the dark forms. The crisp outlines of the plumed hat, the woman's delicate features, and the print she examines dominate the composition, and the stylized lettering announcing the exhibition enlivens the surface.

The example in the present exhibition is one of the surviving originals of the poster, which also exists in small reproductions made for the fifth album of *Les maîtres de l'affiche* in 1900, the year after it was designed. The inclusion of it in that series was a boon for Gottlob, ensuring attention he has yet to receive for his paintings of Parisian boulevards. (See nos. 32, 35 for comments on *Les maîtres de l'affiche*.)

Gottlob's poster was created for the same January 1899 exhibition for which Auguste Lepère did an advertisement (no. 45). One artist chose to dwell on the experience of the print lover, and the other on that of the printmaker.

No. 45
AUGUSTE LEPERE. French, 1849–1918.
2e exposition des peintres-lithographes/Salle du Figaro
Lithograph
1899
430 x 610 mm.
Printed by Lemercier, Paris

Reference: Malhotra II, no. 532.

 This scene of an artist drawing on a lithographic stone is unusual in that he is working not in a studio but outdoors, transferring his impressions of a Paris landscape directly onto the stone. The lithographic medium is nicely suited to free-hand sketching; the only drawback to outdoor work is the need to carry around a heavy stone. Here the stone is propped on a balustrade. Lepère lived in the vicinity of Notre Dame, which stands in the distance. The subsidiary figures are his wife and children.

 The representation of an artist sketching outdoors is appropriate for a poster advertising an exhibition of the work of painter-lithographers because it stresses the creative process, rather than the technical aspects, of lithography. The serious artists who worked in this medium in the later 19th century felt a need to fight the image of lithography as a second-rate, commercial art form; hence the term "painter-lithographer" and the frequent personifications of lithography (see no. 40).

 A comparison between this poster and no. 23, a wood engraving serving as a book illustration, shows how Lepère adjusted his style to the commission and the medium. He used strongly shaded forms for the poster, designed to be seen from a distance, and a more delicate approach for the small print. In both, however, he relied on the same compositional device of a focus on foreground figures.

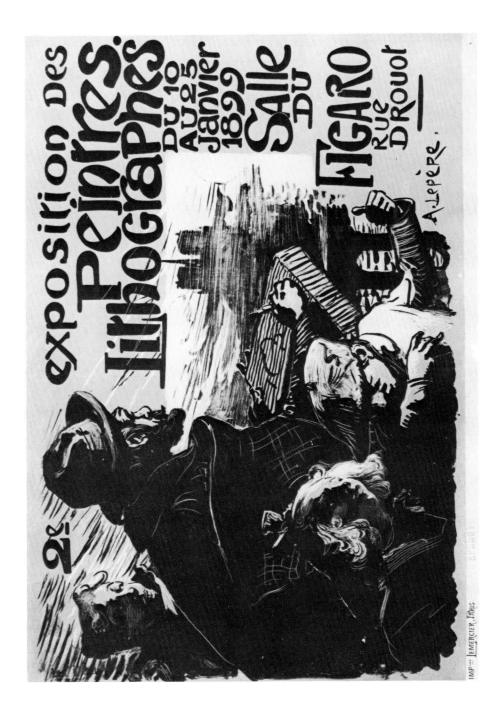

No. 46
PAUL BERTHON. French, 1872–1909.
Salon des arts libéraux
Lithograph printed in color
1900
Edition of 200 without the lettering
598 x 417 mm.

Reference: Victor Arwas, *Berthon and Grasset* (London, 1978), frontispiece and p. 103.

Because of the rage for poster-collecting during *la belle epoque*, artists sometimes printed special editions of their posters without lettering. These editions were possible only when posters had been designed in such a way that lettering was not an integral part of the imagery. An outstanding example is Berthon's poster for the Salon of the Liberal Arts, the lettering of which was planned for the margin.

The poster shows two young girls, one of them holding up a sheet of paper with a faint design on it. Part of an ink-roller and one of the handles from a printing press are shown, as if to make sure that the viewer knows that the sheet of paper is a print. In spite of these mundane details, the scene does not seem to take place in the real world. The girls are lost in revery and seem more like goddesses than creatures of flesh and blood.

The most striking aspect of this poster is the exuberant use of pattern. Rich and varied floral designs adorn the dresses, the background and the image on the print within the print. Such riots of pattern are carryovers from Japanese prints and from the *Intimiste* painting tradition, best known in domestic interiors by Vuillard. Berthon too was a painter, and his handling of pattern and idealization of the female in this poster are also typical of his painting style.

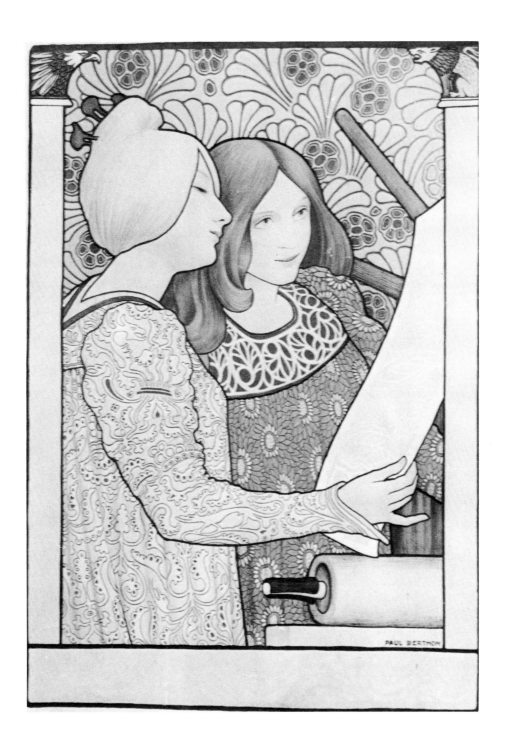

No. 47
HENRI-GABRIEL IBELS. French, 1867–1936.
Femme rehaussant des estampes
Lithograph
Ca. 1900
200 x 180 mm.

The woman here is an artist at work, a refreshing change from the usual society lady or goddess. The title tells us that she is touching up prints. Perhaps she is adding colors to black-and-white prints, as had been commonly done in earlier generations (see nos. 5 and 9) and occasionally thereafter. No painting supplies are shown, but the artist does appear to be holding a brush. She sits on the edge of an armchair and bends over a round table, her body tense with concentration, as she works on one of several prints stacked on the table. Others lie scattered on the floor.

Since Ibels had a half-sister, Louise, who was a printmaker, perhaps it is she who is represented. The woman could also be a friend of his or a studio assistant. Her pose must have been what attracted him to this scene, which is clearly a sketch from life. The work is an effective figure study, its print-related subject matter secondary.

Ibels supplied prints for *L'estampe originale* (see no. 31), and his many posters included one for the *Salon des cent*. A teacher of applied arts, he was a dramatic author as well.

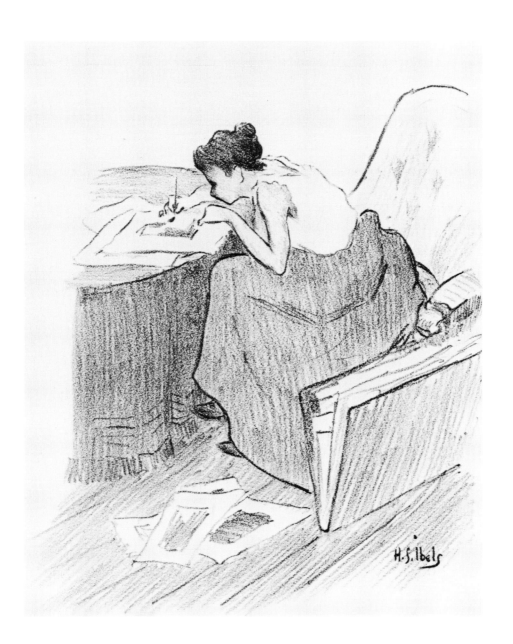

No. 48
SIR FRANK SHORT. British, 1857–1945.
After **G. P. JACOMB-HOOD.** British, 1857–1929.
Franck Seymour Haden, alt. 74
Mezzotint
1901 after painting of 1892
Signed by both artists and annotated "nice proof" by Short
320 x 392 mm.

Reference: Martin Hardie, *The Etched and Engraved Work of Sir Frank Short* II (London, 1940), no. 75.

The use of the mezzotint medium here recalls an old-fashioned portrait style, the reflection of an undercurrent of nostalgia that, along with more forward-looking trends, affected all the arts in the 1890s and the first decade of the 20th century.

The style evoked in this instance is that of the 18th century, as can be seen by a glance at the portraits of Bernard Picart (no. 1) and Pieter Tanjé (no. 3), in which the formality of the setting and costume underscore similar images of the printmakers as gentlemen. The display of tools in the foreground strengthens the comparison, and the odd spelling of the sitter's name in the title and the Latin designation of his age (*alt. 74*), reminiscent of the Latin legends in the Picart portrait, confirm that an earlier artistic tradition is being recalled. The choice of style is intended to flatter the sitter by presenting him as an Old Master might have done.

Sir Francis Seymour Haden, the subject of this portrait, was a surgeon, who did not take up art seriously until he was in his forties. He then became a distinguished etcher, primarily of landscapes. Jacomb-Hood, who painted the portrait, was a frequent exhibitor at the Royal Academy. Sir Frank Short, who turned the portrait into a print, was an expert on the many etching and engraving processes. His particular interest in mezzotint is best demonstrated by his adaptations from Turner's *Liber Studiorum*. Both Haden and Short were highly enough regarded to have served as presidents of the Royal Society of Painter-Etchers, and Jacomb-Hood served on the Council of that Society.

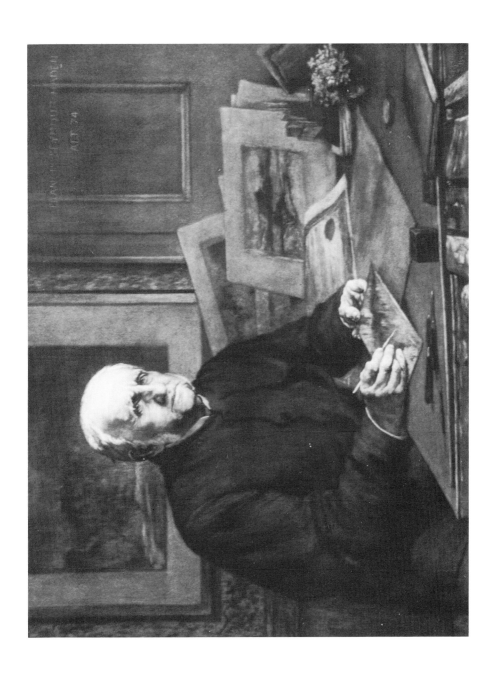

No. 49
GISBERT COMBAZ. Belgian, 1869–1941.
Exposition du croquis et de la caricature judiciaires au Palais de Justice d'Anvers/organisée par la conférence du jeune barreau
Lithograph
1904
506 x 360 mm.

Reference: Francine-Claire Legrand, *Le symbolisme en Belgique* (Brussels, 1971), p. 254 (general comments on the artist).

When in 1904 the junior members of the Belgian bar decided to put on an exhibition of legal sketches and caricatures at the Palace of Justice at Antwerp, they could not have picked a more appropriate artist to do the advertising poster than Gisbert Combaz. He had studied law before becoming both an artist and a professor of art and art history. He responded to the commission in a suitably humorous vein, depicting an outraged lawyer exclaiming over a caricature of a lawyer. His poster fits both the tradition of exhibition posters, in which people look at prints, and the tradition of caricatures, in which people look at prints of themselves.

Combaz is best known for his lithographs but was also a sculptor and a minor Symbolist painter.

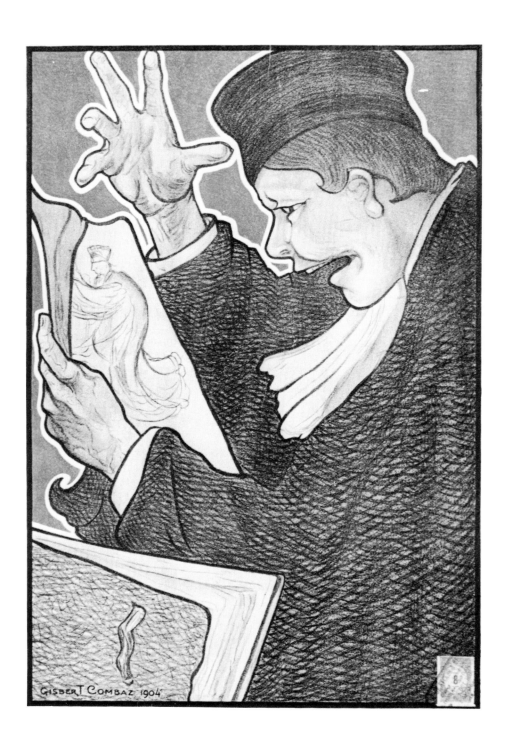

No. 50
JOHN SLOAN. American, 1871–1951.
Connoisseurs of Prints
Etching
1905
Edition of 100
Signed in pencil
114 x 170 mm.

Reference: Peter Morse, *John Sloan's Prints* (New Haven, 1969), no. 127.

John Sloan's *Connoisseurs of Prints* belongs to his "New York City Life" series, a group of etchings with elements of social commentary. Most of them bear strong resemblances to the style of Hogarth or Rowlandson, but this one evokes the work of Daumier. Daumier did a number of satires of gallery visitors, and an 1865 lithograph of his has been mentioned as a possible source for this work (see Morse 127). Sloan's scene was done on the occasion of a print exhibition at the American Art Galleries. The artist included a figure of himself, on the far right, among the satirized connoisseurs.

Sloan's imitation of Daumier and other social satirists in the etchings of this series throws some light on his painting style and helps to explain the genesis of the Ashcan School, which was so labeled because the painters were willing to show the seamier sides of the life around them, the back alleys, rather than the grand facades. Sloan was a leader of this movement.

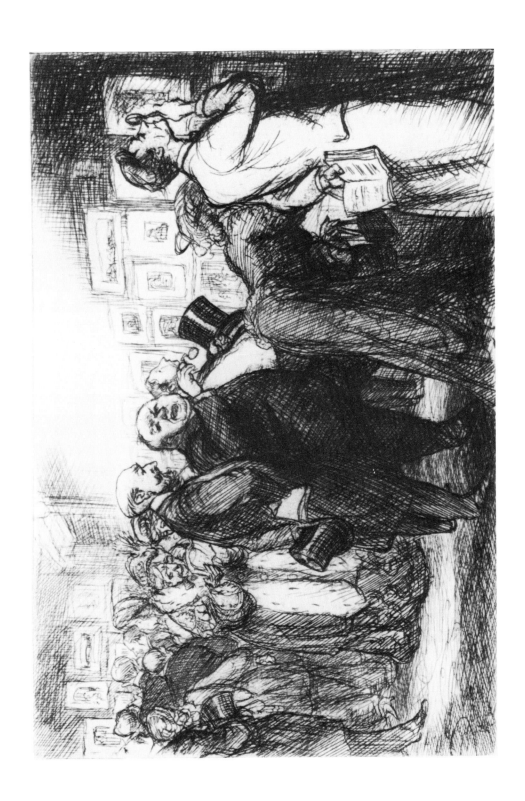

No. 51
MANUEL ROBBE. French, 1872–1936.
Nocturne (or *Le flirt*)
Aquatint printed in color
Ca. 1906
Edition of about 100
347 x 442 mm.

Reference: Merrill Chase Galleries, *Manuel Robbe* (Chicago, 1979), no. 62.

The three Robbe prints included in the exhibition (nos. 51–53) have in common an air of quiet romance. In this one, the setting is a studio, with prints strewn about. The man and woman may have been looking at prints, but they have become distracted and are now engrossed in each other. The invitation "Come up and see my etchings" seems to have had its desired effect. The title, "Nocturne," suggests appropriate background music for a seduction scene, and the sculpted male head and the vase of flowers behind the couple provide a visual counterpoint of male and female symbols for the little drama. The soft colors add to the harmonious effect.

The artistic influences on Robbe were many and varied, but all were incorporated into a very personal style. The works shown here are related to the gentle interiors of the *Intimiste* tradition, with a hint of the psychological content of Symbolism. In addition to his many studies of women, Robbe also did landscapes and records of peasant life. A large number of his prints suggest an admiration for Courbet; others reflect the paintings of Millet, Monet, Manet, Renoir, Gauguin, and Redon.[1]

[1]For further information on his work, see the two Merrill Chase Galleries catalogues, *Manuel Robbe* (Chicago, 1979) and *Manuel Robbe* (Chicago, 1980), both of which contain excellent introductory essays by Gabriel Weisberg.

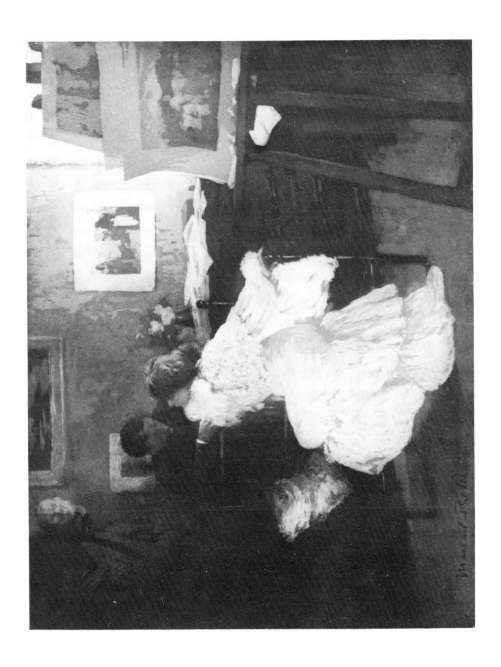

No. 52
MANUEL ROBBE. French, 1872–1936.
Le choix de l'estampe (or *Femme à l'estampe*)
Aquatint printed in color
Ca. 1906
Edition of about 100
530 x 380 mm.

Reference: Merrill Chase Galleries, *Manuel Robbe* (Chicago, 1979), no. 35. Victor Arwas, *Belle Epoque Posters and Graphics* (New York, 1978), ill. p. 66.

A trademark of Robbe's prints is their similarity to oil paintings. He chose to work in aquatint and exploited its technical possibilities in order to achieve a fullness of form and a richness of tone characteristic of painting. His skill is apparent in both his color and his black-and-white aquatints.

The fluid modeling in this softly colored print provides a good example of Robbe's style. By the contrast between the rectilinear composition and the feminine subject matter, he conveyed gentleness and delicacy without lapsing into sentimentality. The size of the print, unusually large for an aquatint, may again reflect Robbe's desire to imitate painting.

Robbe seems to have been particularly fond of the theme of women looking at prints, and he created some of the most captivating renditions of the theme. Certain details here suggest the influence of Manet's famous portrait of Zola, which shows that author holding one of his books. Robbe's lady, who instead holds a print turned so that the viewer can see the image on it, is in a similar pose, and her feet are similarly cropped.

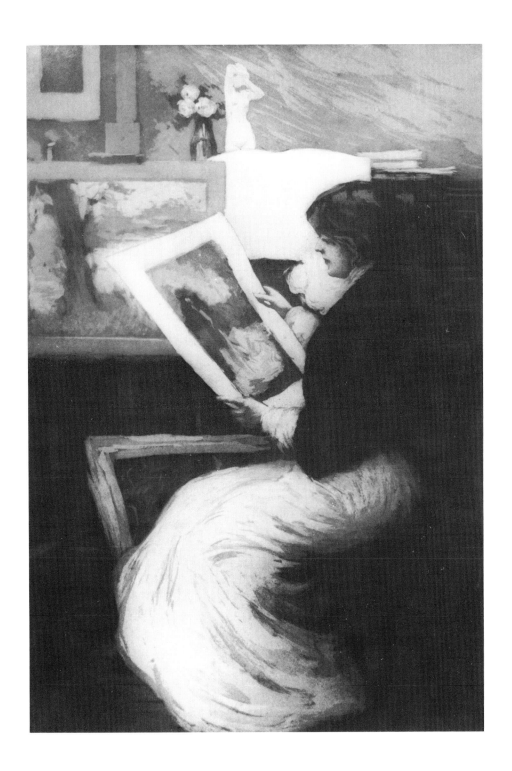

No. 53
MANUEL ROBBE. French, 1872–1936.
Femme regardant des épreuves
Etching and aquatint
Ca. 1907
Edition of about 100
Signed in pencil
495 x 366 mm.

The woman looking at prints here is not fashionably dressed, but rather fashionably undressed, with her undergarment falling seductively off her shoulders. Robbe was free to ignore the requirements of decorum because he was not advertising a gallery, at least not overtly. In a way, the print is a subtle advertisement for his own work, however, and by extension for his dealer, Sagot. Here the viewer sees three sample Robbe prints of different types: the winter landscape scene on the wall, the scene with two nude figures that the woman is admiring, and this print itself.

Why did Robbe show the woman partially clothed? She is clearly a model, posing for him in his studio, which suggests that he was intrigued by the notion of showing a traditional subject of art, the model, looking at art. Other works of his confirm this.[1] Of course, displaying a bit of female flesh in an unexpected context may also have appealed to him. One of his naughtier prints shows an almost-nude librarian.[2]

[1]Merrill Chase Galleries, *Manuel Robbe* (Chicago, 1979), no. 25.
[2]*Ibid.*, no. 13.

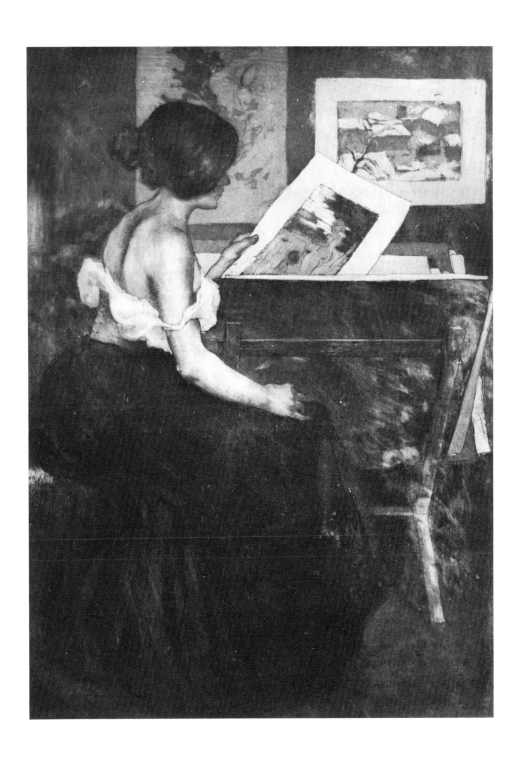

No. 54
MUIRHEAD BONE. British, 1876–1953.
Self-Portrait
Drypoint
1908
Edition of 275
152 x 130 mm.

Reference: Campbell Dodgson, *Etchings and Drypoints by Muirhead Bone* I (London, 1909), frontispiece.

The conventional attributes of tools, plates and other equipment used to identify printmakers in portraits appear to a lesser extent in the category of self-portraits. In this self-portrait, Muirhead Bone let his viewers know that he was a printmaker by strewing about the foreground a few sheets of paper with dark rectangles in the center that identify them as prints. Although he showed himself at work, we deduce that he is actually working on a copper plate, rather than making a drawing, only because we are looking at the finished product of a work done on such a plate. Bone could have manipulated the composition to show better the details of what he was doing but was content to make a faithful record of what he saw in the mirror, without contrivance. The unassuming man before him, bundled up against a chilly day, lives on through this print.

Bone is best known for his drypoints of architectural subjects, done in a precise style that reflects his training as an architect. His works are now quite rare, because most of them were printed in very limited editions, often of five or fewer impressions.[1] This one has a larger edition than usual because it was done for Dodgson's book.

[1]Kenneth M. Guichard, *British Etchers 1850–1940* (London, 1977), p. 27.

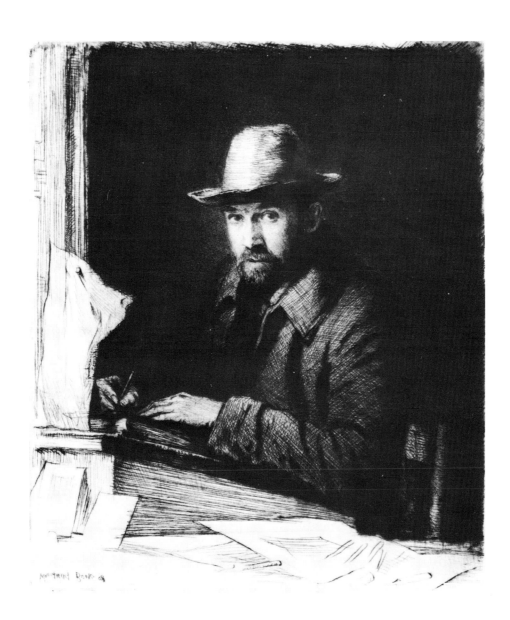

No. 55
JOHN BARCLAY. British, born 1876.
The Proof
Etching
Ca. 1900–1910
Signed and numbered (no. 9)
200 x 196 mm.

 The Proof seems to have been created simply as a work of art, rather than as the result of a commission to advertise a specific exhibition or book. Perhaps it is for this reason that the subject matter is secondary to the formal aspects of the work. Although a man is shown looking at a print, the most striking feature is the geometric pattern of the background. The artist has flattened the space and experimented with bold rectangles of light and dark. The skillful placement of the figure against the pattern results in a composition that is at once asymmetrical and balanced.
 Barclay's style both reflects works of an earlier generation and foreshadows something new. The deceptively casual composition and the flat background recall Degas and his contemporaries, while the subordination of subject matter hints that abstract art is on its way.
 To achieve such large areas of black and the slightly blurry image that he wanted, Barclay probably left the plate in acid for a longer time than usual. With this method, the particularly deeply etched lines retain large amounts of ink, which smears when printed. Although most etchers would prefer to avoid this effect, Barclay strove for it and exploited it to his own advantage.

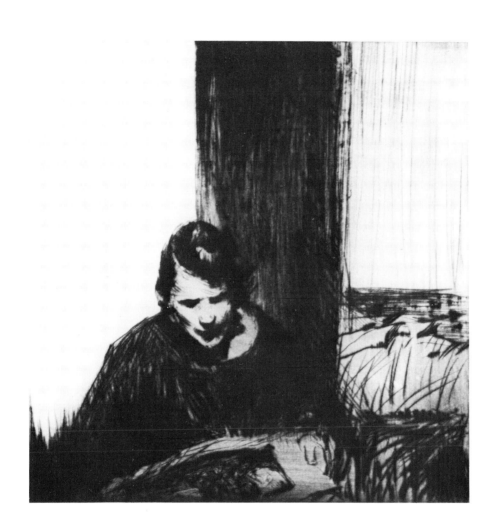

No. 56
JOHN SLOAN. American, 1871–1951.
The Amateur Lithographer (alternative title: ***Beginners***)
Lithograph
1908
2nd state of two
Signed by the artist and annotated "10 proofs printed, stone destroyed"
414 x 381 mm.

References: Peter Morse, *John Sloan's Prints* (New Haven, 1969), no. 144(2). David W. Scott and E. John Bullard, *John Sloan 1871–1951* (Boston, 1971), no. 59.

Although Sloan was an experienced etcher at the time this print was done, he was a novice at lithography. The energetic figures here are Sloan himself (on the right) and his friend Moellmann, a professional printer who was helping him out in his first attempt at working a lithographic press. Sloan had borrowed a press from Arthur Dove. He dashed off this sketch just in order to experiment with the printing of it. The scene is a wry, self-deprecating comment on his hapless situation.

Not only does the preparation of the design on a lithographic stone require a technique different from that on an etching plate, but the presses for the two media also have to be constructed differently. Using a lithographic press, built to accomodate a large stone, takes some practice. In fact, most artists, whether or not they are accustomed to the medium, tend to put the design on the stone and then leave the actual printing to professional printers.

Sloan's interest in lithography was short-lived. He preferred etching, and only did ten lithographs out of three hundred prints. For two other prints by Sloan, see nos. 50 and 57.

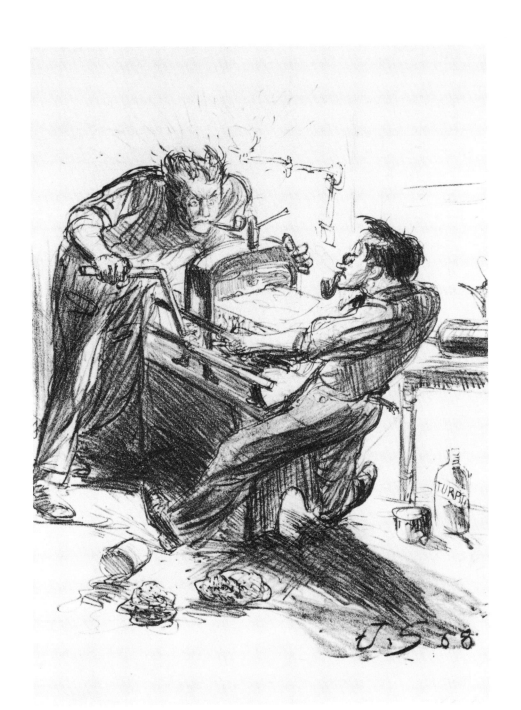

No. 57
JOHN SLOAN. American, 1871–1951.
Woman with Etching Tray
Etching
1912
Edition of 175
Signed "John Sloan per HFS" (Sloan's widow Helen Farr Sloan)
95 x 70 mm.

Reference: Peter Morse, *John Sloan's Prints* (New Haven, 1969), no. 154.

Prints of women involved in the printmaking process usually show them carrying out subsidiary steps, rather than creating the original designs. The exceptions are those depicting idealized women—muses or personifications—rather than actual artists. The woman here is no exception. Exactly what she is doing is not clear, but, rather than holding the etching needle used to create the design, she holds a brush. She may be waiting to brush air bubbles away while the prepared plate sits in an acid bath, or she may be about to apply stopping-out varnish. According to Sloan's cataloguer, Morse, the woman is probably a student of Sloan's named Mrs. Bernstein.

The handling of the highlights and shadows suggests that the artist had some acquaintance with 17th-century Dutch genre scenes of women in interiors. Another print by Sloan (no. 50) makes a more explicit reference to a past style.

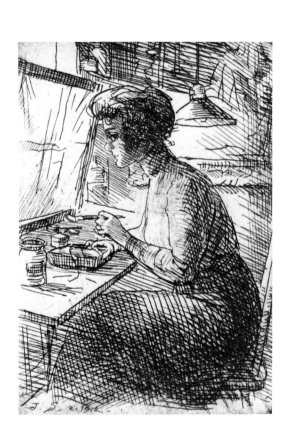

No. 58
CHILDE HASSAM. American, 1859–1935.
Portrait of Joseph Pennell
Lithograph
1917
Edition of 83
Signed in pencil with monogram
390 x 285 mm.

Reference: Fuller Griffith, *The Lithographs of Childe Hassam* (New York, 1980), no. 3.

 This portrait of the artist Joseph Pennell at work in his studio is daring in its placement of the central figure with his back to the viewer. The setting includes an array of supplies and a printing press. Pennell is hunched over in front of a large window, with his arms bent as if to lift something. By calling the scene a portrait, Hassam reveals his belief that the image of Pennell at work has captured the essence of the man.

 Pennell must have been a very hard worker, for he left an enormous *oeuvre* of etchings, lithographs, and watercolors. During 1917 alone, he produced more than a hundred lithographs, primarily scenes of engine factories and other industrial subjects related to the war effort.

 Childe Hassam, a Bostonian, made his reputation as a painter, and became one of the foremost American Impressionists. As a graphic artist, he was primarily an etcher, but in 1917, when he was 58, he began to experiment with lithography. This lithograph is one of only 45 that he produced, all of which were printed by George C. Miller (see no. 68). Both Hassam and Pennell were interested in the artistic possibilities of lithography, which allows greater massing of forms than does its sister medium, etching. The loose, free strokes of Hassam's lithographic crayon here and the momentary nature of his subject are consistent with his background as an Impressionist.

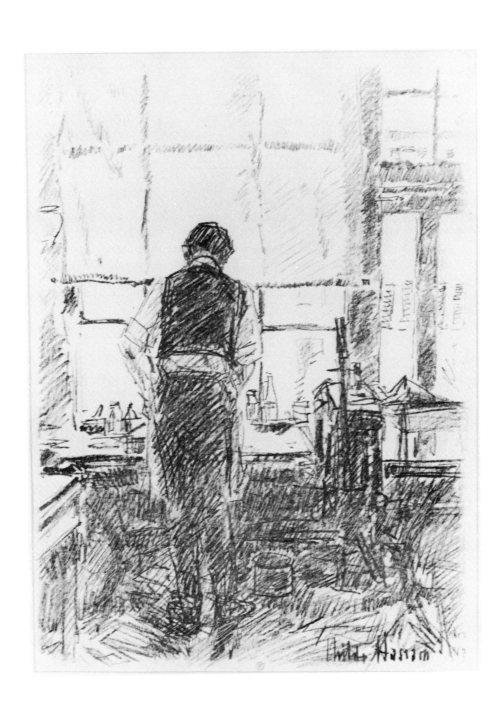

No. 59
DWIGHT C. STURGES. American, 1874–1940.
Plate Printer #1
Drypoint
1917
Edition of 30
Signed
208 x 243 mm.

Reference: Natalie Sturges Butler, *Dwight C. Sturges, Etcher of an Era* (Freeport, Me., 1974), p. 94.

 This printer examines a proof that has just come off the press, checking for quality. The image conjures up memories of craftsmen in the old tradition, with their pride in the creation of individual objects. Here is a man who still has the patience and the concern to give loving attention to all aspects of his work.

 Dwight Sturges worked for many years as an illustrator for the *Christian Science Monitor* in Boston. The realism of his work is typical of American art in the first decades of the 20th century; combined with the close-up focus, it may reflect the influence of the New York Ashcan School.

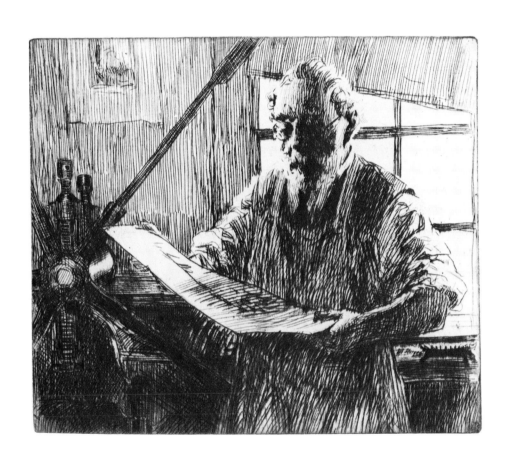

No. 60
DWIGHT C. STURGES. American, 1874–1940.
Plate Printer #2
Etching
1919
Edition of no more than 100
Signed
235 x 189 mm.

Reference: Natalie Sturges Butler, *Dwight C. Sturges, Etcher of an Era* (Freeport, Me., 1974), p. 95.

As in Sturges' previous representation of a printer (see no. 59), we have here a view of the craftsman at work. This time he is captured in the act of operating a printing press, his knowing hands running the wheel and the table of the press in tandem. Sturges made the composition energetic not only by means of forcible gestures but also by means of the large wheel in the foreground, which dominates the scene and conveys an impression of motion.

Sturges' mastery of the etching medium enabled him to use dramatic lighting to enhance his effects. Where he wanted deep shadows, he achieved wonderfully rich, dark areas through a build-up of fine lines; where he wanted highlights, he left the forms as bare as possible of line, as on the man's forearm. Through his skill, he has endowed this simple scene with monumentality.

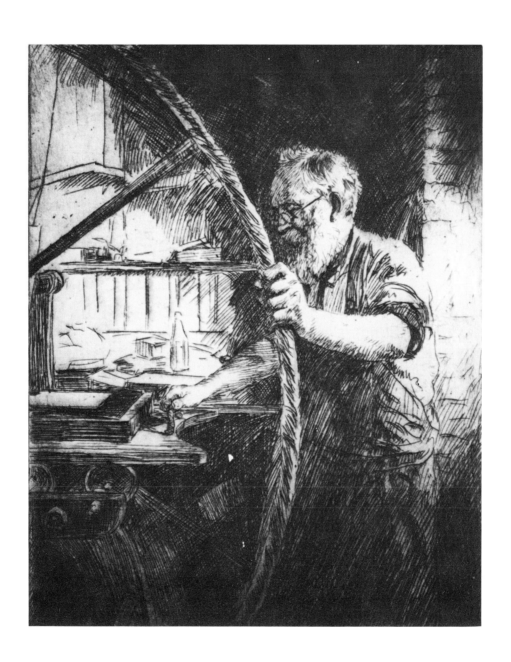

No. 61
GEORG JILOVSKY. Czechoslovakian, born 1884.
Ex Libris Dr. Hugo Fuchs
Etching
1919
Signed
135 x 94 mm.

The man doing the looking here is the owner of the bookplate, Dr. Hugo Fuchs, and Jilovsky has managed to depict him humorously but without disrespect. It certainly would not offend anyone to be dwarfed by great masterpieces of art and architecture. The doctor is shown admiring a Rembrandt etching (a portrait of the artist's mother) and a Greek temple.

The Munich-trained Georg Jilovsky is best known for his bookplates, of which he did a great many. It is a pity that the use of paperback books has rendered book-plates obsolete, for the custom-made bookplate once allowed individuals with less than princely incomes to own original works of art designed expressly for them.

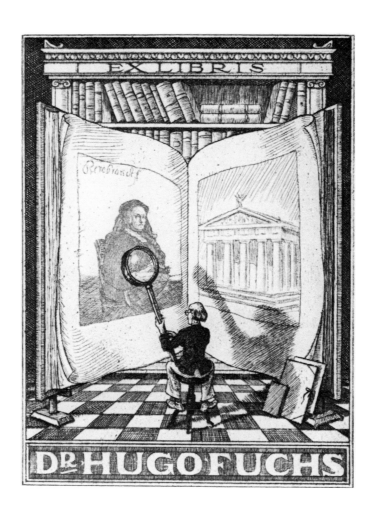

No. 62
ROBERT BONFILS. French, 1886–1972.
L'atelier d'estampes
Woodcut printed in color
1921
Signed in pencil
Edition of 140
309 x 295 mm.

The appeal of this print lies in the artist's exuberant approach to the woodcut. The theme is the making of woodcuts, and the print itself is a virtuoso display of the possibilities of the medium. The protagonists of the scene are a man in the foreground, who is removing a freshly printed woodcut from its block, and a woman in the background, who holds a large print up for viewing. A female face peers at us upside down from the woodblock and its mirror image from the print that the man is carefully peeling back. In executing the scene, Bonfils played up the jagged quality of designs gouged from wood, using such devices as the sawtooth sleeve and shadow on the background woman and the spiky hairline and eyelashes of the woman on the subsidiary print. His technique underscores the contrast between positive and negative shapes throughout the print, a contrast that is enhanced by the use of colors.

Because of the opportunity it gave him to draw attention to reversals of form, the selection of the final stage of printmaking was perfect for Bonfils. The outcome is a satisfying work of art, which rises above mere illustration of technique.

Robert Bonfils was a painter and printmaker who exhibited at the Salon d'Automne and the Salon des Tuileries; he also served as a member of the committee of the Salon d'Automne.

No. 63
JEAN–EMILE LABOUREUR. French, 1877–1943
Les amateurs d'estampes (card for the publisher H.-M. Petiet)
Etching with engraving
1925
Third state of three
Signed and annotated no. 20
82 x 115 mm.

Reference: L. Godefroy, *L'oeuvre gravé de Jean–Emile Laboureur* (Paris, 1929), no. 319.

Laboureur's amusing etching is the latest in our exhibition to show print lovers examining prints at a gallery. This theme had fallen out of use as the great *belle epoque* print boom ended. When Laboureur got a commission from Petiet, he must have turned for inspiration to the announcements of another publisher-dealer, Sagot, as well as to other print-related advertisements of the 1890s. The sentimentality of the scenes with society ladies was no longer in fashion in the 1920s; the artist avoided it by showing men only.

Laboureur has given enough details so that the viewer is in no doubt that the setting is a print gallery; there are loose prints, lots of portfolios, and a print cabinet in the back. He did not, however, arrange the prints so that the images on them can be seen. The deft, seemingly casual composition makes the gallery seem inviting, and the pear-shaped figures, one of whom may be M. Petiet himself, are delightful.

Laboureur's other etchings include more abstract Cubist-inspired works, along with winsome records, like this one, of Parisian life.

No. 64
PEGGY BACON. American, born 1895.
Peter Platt Printing
Etching
1929
Signed, titled and dated by the artist, and annotated "1st print"
151 x 103 mm.

Reference: Peter Morse, *John Sloan's Prints* (New Haven, 1969), fig. 3.

By picking the moment when the printer of etchings is reaching out for a piece of fabric with which to wipe an inked plate, Peggy Bacon draws attention to the aspect of his job which requires the most skill. In order to introduce ink into the etched furrows that will make the lines of the printed design, the printer has first to roll ink across the entire etching plate and then to remove the ink that has adhered to the flat main surface. If he wipes away too much, the impression will be dry and lifeless; if he leaves too much, the image will be obscured. Apparently the special talent of Peter Platt, in Bacon's view, was in knowing exactly how much ink to wipe away. The rich, velvety tones in her etching of him, which he himself printed, show the nature of his handiwork.

Another artist in the exhibition also frequented Platt's workshop in New York. John Sloan (nos. 50, 56, 57) took etching plates to Platt for printing between 1927 and 1934. Bacon's distinctly American brand of realism shows affinities with that of Sloan.

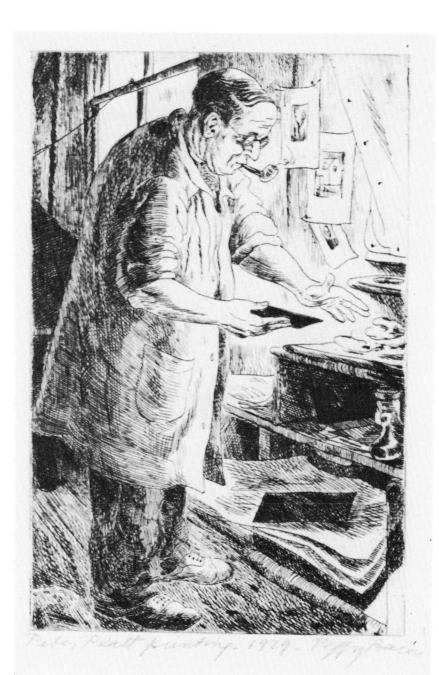

Peter Platt, printing. 1929. Peggy...

No. 65
EDGAR HOLLOWAY. British, born 1914.
The Etcher (2nd Plate)
Etching
1930s
Signed in the plate and in pencil
134 x 126 mm.

 This portrait study follows in the tradition of Rembrandt and Frans Hals, the grand masters of portraiture. Holloway has striven for the same penetration of personality, and has achieved it to a certain degree in the expressive eyes of the sitter. The resulting print suggests that this artist's work deserves to be better known than it is. A painter and etcher, who had his first one-man show in London when he was still a teenager, Holloway has not achieved a reputation outside England.

 The task of showing an etcher at work is a difficult one, more difficult than that of showing a painter or sculptor because of the challenge of making the nature of the activity understood. The printing press in the background helps us to identify the surface on which the artist is drawing as an etching plate, so that we do not need the title to know that we are looking at an etcher. The ambiguous nature of the design on that plate makes it uncertain that this study is a self-portrait, but the etcher looks out at the viewer with the intense gaze of one working from a mirror.

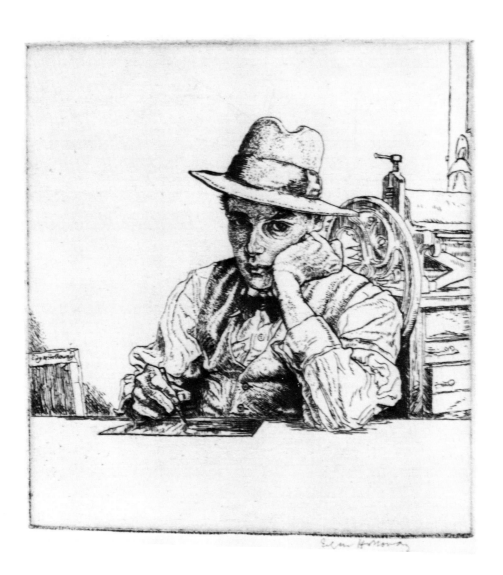

No. 66
LAWRENCE KUPFERMAN. American, born 1909.
The Printer.
Drypoint
1937
225 x 177 mm.

The young printer here might almost be throwing a javelin rather than operating a printing press. His heroic gesture, together with the strict geometry of the composition, which freezes the action, lends to the figure a timeless, idealized quality. Kupferman's selection of the one stage in the printmaking process that requires brute strength and his glorification of the printer's physical labor reflect the social outlook of the New Deal era. The young man depicted here was an apprentice printer for Harvard University diplomas.

The Printer is an early work by a Boston artist who is best known for his abstract paintings. He has done prints, watercolors, oils and acrylics.

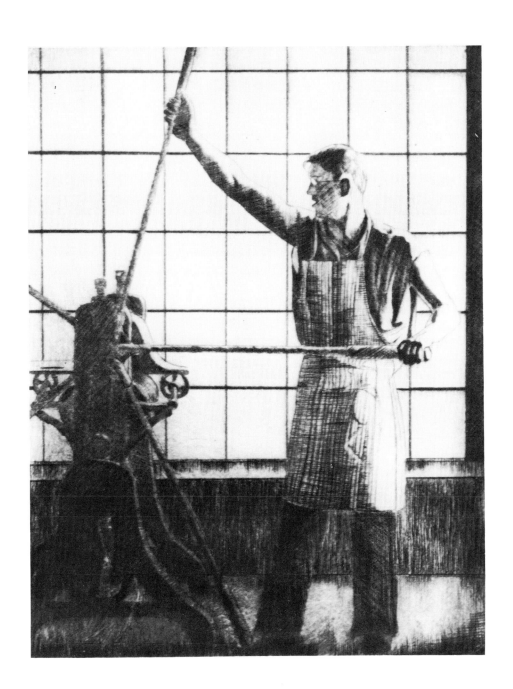

No. 67
KEITH SHAW WILLIAMS. American, 1906–1951.
Stow Wengenroth Making a Print
Etching
1939
203 x 303 mm.

Reference: Ronald and Joan Stuckey, *The Lithographs of Stow Wengenroth 1931–1972* (Boston, 1974), frontispiece and p. 17.

 This rather serious print, the only one in the exhibition to record an aspect of printmaking in painstaking detail, is in one medium, while its subject is the making of a print in another medium: It is an etching on the subject of lithography. The etching, a portrait of the landscape artist Stow Wengenroth at work on his 1939 lithograph *Owls*, illustrates his habits of drawing on the stone with a paper under his hand, to prevent grease from rubbing off onto the stone, and of using for reference a preparatory drawing larger in size than the image he put on the stone. Although its instructional tone keeps Williams' etching from rising above the level of illustration, his straightforward approach and the realism of Wengenroth's work as well are part of a long tradition of realism in American art, which was particularly strong in the 1930s.

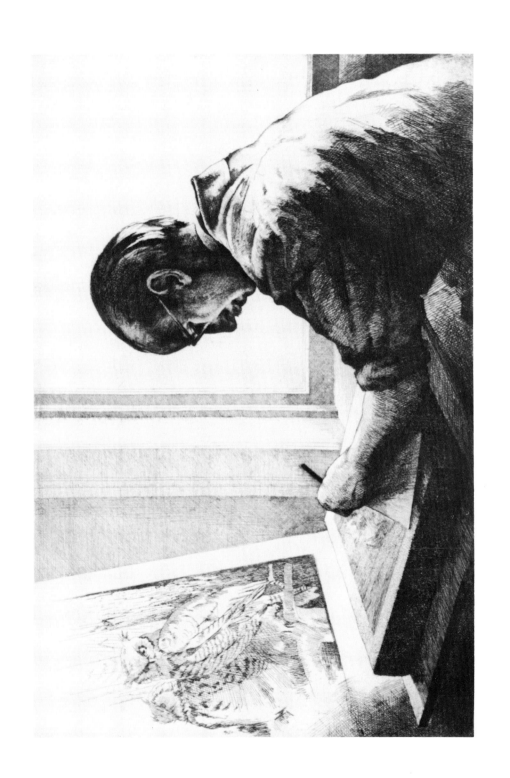

No. 68
ELLISON HOOVER. American, 1888–1955.
George C. Miller, Lithographer
Lithograph
1949
Signed in pencil
Edition of 30–50
282 x 223 mm.

Reference: Lauris Mason, *The Lithographs of George Bellows* (New York, 1977), ill. p. 24.

The most explicit recognition that a graphic artist can render to a printer, who ordinarily works behind the scenes, is to put him in the limelight by making him the subject of a work of art. The man so honored here is George C. Miller, a leading New York lithographic printer during the first half of this century. Ellison Hoover has portrayed him as a serious, reflective man, one whom we can imagine doing careful, conscientious work.

Hoover has evoked the printer's environment not only through his inclusion of tools but also through his arrangement of tonal values. Putting the figure in front of a bright window has allowed the use of broad areas of dark tones in the remainder of the scene, creating a somber setting appropriate to the heavy equipment associated with the printing process.

Some. of the artists for whom Miller printed were George Bellows, Joseph Pennell, Childe Hassam (no. 58), Lionel Feininger, Marsden Hartley, Reginald Marsh, and Stow Wengenroth (no. 67). According to Wengenroth and Lynd Ward, his talents included an ability to adjust his technique to suit the individual needs of the artists, and a skill at the difficult task of printing uniformly throughout an edition.[1] Miller's son Burr Miller now operates his father's firm, and has maintained its reputation for fine work.

[1]"George C. Miller, Master Printer," *American Artist* (May, 1966), pp. 12–13.

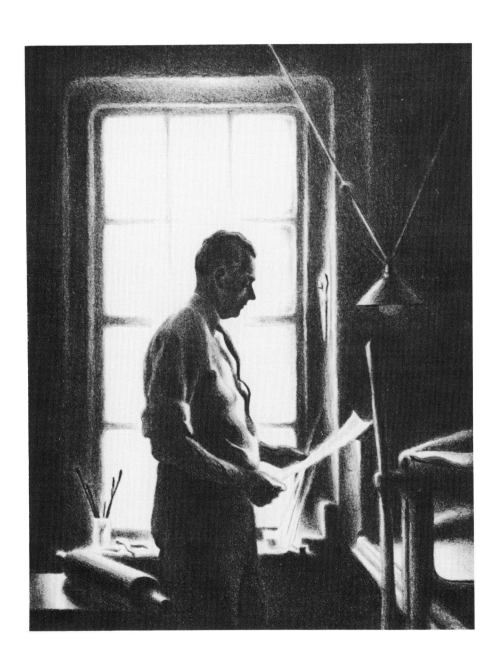

No. 69
A. PAUL WEBER. German, born 1893.
Die Exclusiven (The Initiated)
Lithograph
1959
Dated 4/7/59 on stone
Signed in pencil
360 x 460 mm.

Reference: George Ramseger, A. *Paul Weber Graphik* (Hamburg, 1956), no. 27
(1953/54 version of theme).

 Weber's caricature is a double-pronged attack on art snobs and modern art.
One of the works about which his strutting ducks and hen chatter so knowingly is a
well-known Picasso lithograph (Bloch no. 389)—modified to include a smirking
nude lady. The other is a Constructivist work. The vision of birds instead of human
figures standing in an art gallery is refreshingly absurd.

 The type of satire in which animals dress as humans and ape their activities has
a long tradition, stretching back to ancient Egyptian scenes on papyrus in which
mice dressed as noble ladies are attended by servant cats.

 This print has the lightest theme of all Weber's satirical works. The others are
frequently as bleak as Goya's *Disasters of War.*

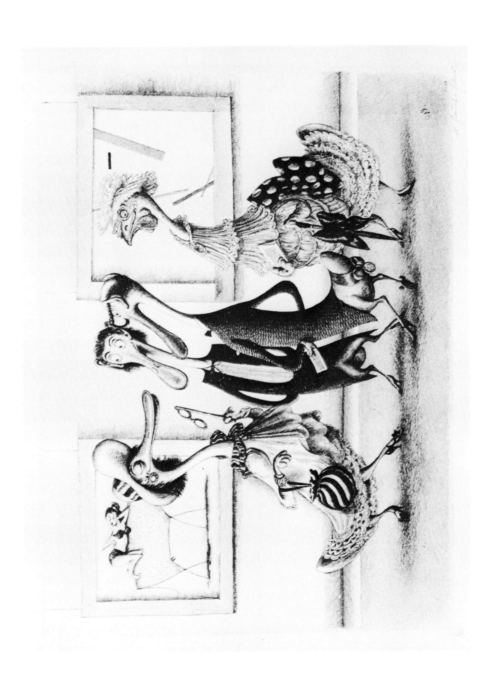

No. 70
PHILIPPE MOHLITZ. French, born 1941.
Les impenitents (artiste et amateurs)
Etching
1970
Artist's proof
Signed in pencil and annotated E/A
205 x 120 mm.

Reference: Reinhold Kersten and Walter Koschatzky, *Mohlitz* (New York, 1977), ill. p. 74.

In this unsettling, nightmarish vision by the contemporary French artist Mohlitz, the participants are a dead or dying human figure chained to the handle of a printing press and three spectral figures, heads and bodies wrapped in white, who scrutinize a print that one of them is peeling from the press. The scene takes place in a gloomy, medieval sort of interior anachronistically lit by electric bulbs. What makes it eerier is that there is daylight outside. The white figures could be either ghosts of the dead or creatures from outer space, visitors from past or future.

The scene is deliberately mysterious. Mohlitz, however, seems to have represented an artist as victim and his collectors as adversaries, an unusual approach which makes his print stand apart from the others in the exhibition. His ironic title, *The Unrepentant (Artist and Art lovers)*, suggests that neither can help doing what they do.

The influences on Mohlitz range from Dürer to Piranesi to the Surrealists. The same very personal style, a curious blend of the monumental and the playful, is apparent in his other works, which are primarily engravings. He is the youngest artist represented here, having been born in World War II. His new handling of the subject of printmaking is noteworthy.

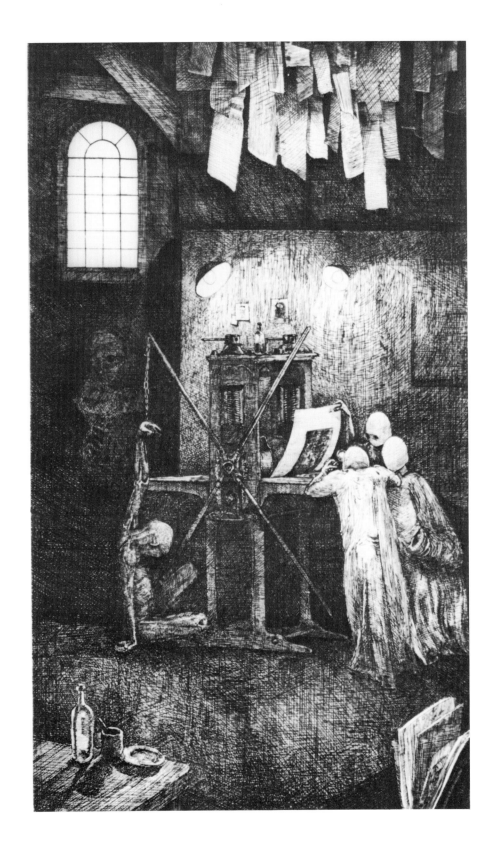

LIST OF ILLUSTRATIONS

No. 1
NICOLAS VERKOLJE. Dutch, 1673–1746.
After **JEAN-MARC NATTIER.** French, 1685–1766.
Portrait of Bernard Picart
Mezzotint
1715 after painting of 1709

No. 2
NICOLAS VERKOLJE. Dutch, 1673–1746.
After **ARNOLD HOUBRAKEN.** Dutch, 1660–1719.
Portrait of Jakob Moelart
Mezzotint
Ca. 1727 after painting of ca. 1710–19

No. 3
PIETER TANJE. Dutch, 1706–1761.
After **J. M. QUINCKHARD.** Dutch, 1688–1772.
Portrait of Pieter Tanjé
Engraving with etching
1760

No. 4
JOHANN ELIAS HAID. German, 1739–1809.
After **JACOB METTENLEITER.** German, 1750–1825.
Portrait of Mettenleiter and Haid
Mezzotint
1784

No. 5
ISAAC CRUIKSHANK. British, 1764–1810/11.
After **GEORGE M. WOODWARD.** British, 1760?–1809.
The Caricature Magazine or Hudibrastic Mirror
Frontispiece to vol. I
Etching, hand-colored
1807

No. 6
THOMAS ROWLANDSON. British, 1757–1827.
After **GEORGE M. WOODWARD.** British, 1760?–1809.
The Genii of Caricature Bringing Fresh Supplies
Tail-piece to vol. III of *The Caricature Magazine*
Etching, hand-colored
1809

No. 7
THOMAS ROWLANDSON. British, 1757–1827.
After **JEAN-FRANÇOIS BOSIO.** French, 1727–1832.
Les musards de la rue du coq à Paris
Etching, hand-colored
Ca. 1807–15, after engraving of 1802

No. 8
NICOLAS-TOUSSAINT CHARLET. French, 1792–1845.
"Tu vois Austerlitz au moment du tremblement!"
Lithograph
1827

No. 9
CHARLES JOSEPH TRAVIES. French, 1804–1859.
"Ces diables de députés! qué drôles de boules ils ont!"
Lithograph, hand-colored
1833

No. 10
HONORE DAUMIER. French, 1808–1879.
"Oursikoff!... trouvez-vous cela ressemblant?"
Lithograph
1854

No. 11
A. P. MARTIAL. French, 1828–1883.
Le siège de la societé des aquafortistes
Etching
1864

No. 12
FELICIEN ROPS. Belgian, 1833–1898.
La presse (Imprimerie en taille douce/F. Nys)
Etching
Before 1878

No. 13
HENRY SOMM. French, 1844–1907.
Chez l'imprimeur
Etching
1880s

No. 14
HENRY SOMM. French, 1844–1907.
Imprimerie artistique/A. et Eugène Delâtre
Etching
Ca. 1887
Early state, without lettering

No. 15
FELIX BUHOT. French, 1847–1898.
Les salles d'estampes
Etching with engraving, aquatint, and drypoint
1887

No. 16
NORBERT GOENEUTTE. French, 1854–1894.
L'amateur d'estampes
Etching
1880s

No. 17
JULES CHERET. French, 1836–1932.
Frontispiece to **Béraldi,** *Les graveurs du XIXe siècle*
Lithograph printed in color
1886

No. 18
EUGENE-ANDRE CHAMPOLLION. French, 1848–1901.
After **HECTOR GIACOMELLI.** French, 1822–1904.
Frontispiece to **Béraldi,** *Les graveurs du XIXe siècle*
Etching
1886

No. 19
AUGUSTE DELATRE. French, 1822–1907.
Frontispiece to **Béraldi,** *Les graveurs du XIXe siècle*
Etching
1886

No. 20
EUGENE GAUJEAN. French, 1850–1900.
After **DRANER** (pseudonym of **JULES RENARD**). Belgian (worked in France), born 1833.
Frontispiece to **Béraldi,** *Les graveurs du XIXe siècle*
Etching
1887

No. 21
EUGENE GAUJEAN. French, 1850–1900.
After **MAURICE LELOIR.** French, 1853–1940.
Frontispiece to **Béraldi,** *Les graveurs du XIXe siècle*
Etching
1887

No. 22
HENRI FANTIN-LATOUR. French, 1836–1904.
La lithographie
Frontispiece to **Béraldi,** *Les graveurs du XIXe siècle*
Lithograph
1887

No. 23
AUGUSTE LEPERE. French, 1849–1918.
Frontispiece to **Béraldi,** *Les graveurs du XIXe siècle*
Wood engraving
1889

No. 24
AUGUSTE LEPERE. French, 1849–1918.
Frontispiece to **Béraldi,** *Les graveurs du XIXe siècle*
Wood engraving
1890

No. 25
FELIX VALLOTTON. French (born Switzerland), 1865–1925.
Les amateurs d'estampes
Woodcut
1892

No. 26
ALEXANDRE LUNOIS. French, 1863–1916.
E. Sagot éditeurs/Rue Guénégaud 18
Lithograph
Ca. 1890–92

No. 27
ALEXANDRE LUNOIS. French, 1863–1916.
Ed. Sagot/39bis rue de Chateaudun
Lithograph printed in color
1894

No. 28
G. MARIE. French, life dates unknown.
*Edmond Sagot/Affiches, estampes/Etrennes aux dames/
Paris-Almanach*
Lithograph printed in color
1897

No. 29
GEORGE ALFRED BOTTINI. French, 1874–1907.
La galerie Sagot
Lithograph printed in color
1898

No. 30
PAUL HELLEU. French, 1859–1927.
Ed. Sagot/Estampes et affiches illustrées
Lithograph printed in color
Ca. 1898–1900

No. 31
HENRI DE TOULOUSE-LAUTREC. French, 1864–1901.
La lithographie
Cover for 1st year of *L'estampe originale*
Lithograph printed in color
1893

No. 32
FREDERIC-AUGUSTE CAZALS. French, 1865–1941.
7me exposition du salon des 100
Lithograph printed in color
1894
Reduced version, 1896, for *Les maîtres de l'affiche*

No. 33
FERNAND FAU. French, 1858–1917.
Salon des cent/14e exposition/31 rue Bonaparte
Lithograph printed in color
1895

No. 34
FREDERIC-HUGO D'ALESI. Rumanian (worked in France), 1849–1906.
Centenaire de la lithographie/Galerie Rapp
Lithograph printed in color
1895
Reduced version, 1897, for *Les maîtres de l'affiche*

No. 35
JULES CHERET. French, 1836–1932.
Concert d'été
Lithograph
1896
Special plate for *Les maîtres de l'affiche*

No. 36
PIERRE BONNARD. French, 1867–1947.
Exposition/Les peintres-graveurs/Galerie Vollard
Lithograph printed in color
1896

No. 37
OTTO FISCHER. German, 1870–1947.
Kunst-Anstalt für Moderne Plakate/Wilhelm Hoffmann/Dresden
Lithograph printed in color
1896
Reduced version, 1898, for *Les maîtres de l'affiche*

No. 38
ARMAND RASSENFOSSE. Belgian, 1862–1934.
Les affiches étrangères illustrées
Lithograph printed in color
1896

No. 39
ANDREW KAY WOMRATH. American, born 1869.
XXVe exposition/Salon des cent
Lithograph printed in color
1897

No. 40
MARCEL LENOIR (Jules Oury, known as Marcel Lenoir). French, 1872–1931.
Affiches/Estampes/Lithographies/Arnould/7 rue Racine
Lithograph printed in color
Ca. 1895–1900

No. 41
M. P. VERNEUIL. French, 1869–1942.
Executed by **G. DUPRE, DETE,** and **LABAT.**
L'image, cover for 5th issue
Wood engraving, printed in color
1897

No. 42
THEO VAN RYSSELBERGHE. Belgian, 1862–1926.
N. Lembrée
Lithograph printed in color
1897

No. 43
HENRI DE TOULOUSE-LAUTREC. French, 1864–1901.
Le bon graveur—Adolphe Albert
Lithograph
1898

No. 44
FERNAND-LOUIS GOTTLOB. French, 1873–1935.
2e exposition des peintres-lithographes/Salle du Figaro
Lithograph printed in color
1899

No. 45
AUGUSTE LEPERE. French, 1849–1918.
2e exposition des peintres-lithographes/Salle du Figaro
Lithograph
1899

No. 46
PAUL BERTHON. French, 1872–1909.
Salon des arts libéraux
Lithograph printed in color
1900
Early state, without lettering

No. 47
HENRI-GABRIEL IBELS. French, 1867–1936.
Femme rehaussant des estampes
Lithograph
Ca.1900

No. 48
SIR FRANK SHORT. British, 1857–1945.
After **G. P. JACOMB-HOOD**. British, 1857–1929.
Franck Seymour Haden, alt. 74
Mezzotint
1901 after painting of 1892

No. 49
GISBERT COMBAZ. Belgian, 1869–1941.
Exposition du croquis et de la caricature judiciares
Lithograph
1904

No. 50
JOHN SLOAN. American, 1871–1951.
Connoisseurs of Prints
Etching
1905

No. 51
MANUEL ROBBE. French, 1872–1936.
Nocturne (or *Le Flirt*)
Aquatint printed in color
Ca.1906

No. 52
MANUEL ROBBE. French, 1872–1936.
Le choix de l'estampe (or *Femme à l'estampe*)
Aquatint printed in color
Ca.1906

No. 53
MANUEL ROBBE. French, 1872–1936.
Femme regardant des épreuves
Etching and aquatint
Ca.1907

No. 54
MUIRHEAD BONE. British, 1876–1953.
Self-Portrait
Drypoint
1908

No. 55
JOHN BARCLAY. British, born 1876.
The Proof
Etching
Ca. 1900–1910

No. 56
JOHN SLOAN. American, 1871–1951.
The Amateur Lithographer (or *Beginners*)
Lithograph
1908

No. 57
JOHN SLOAN. American, 1871–1951.
Woman with Etching Tray
Etching
1912

No. 58
CHILDE HASSAM. American, 1859–1935.
Portrait of Joseph Pennell
Lithograph
1917

No. 59
DWIGHT C. STURGES. American, 1874–1940.
Plate Printer #1
Drypoint
1917

No. 60
DWIGHT C. STURGES. American, 1874–1940.
Plate Printer #2
Etching
1919

No. 61
GEORG JILOVSKY. Czechoslovakian, born 1884.
Ex Libris Dr. Hugo Fuchs
Etching
1919

No. 62
ROBERT BONFILS. French, 1886–1972.
L'atelier d'estampes
Woodcut printed in color
1921

No. 63
JEAN-EMILE LABOUREUR. French, 1877–1943.
Les amateurs d'estampes (card for the publisher H.-M. Petiet)
Etching with engraving
1925

No. 64
PEGGY BACON. American, born 1895.
Peter Platt Printing
Etching
1929

No. 65
EDGAR HOLLOWAY. British, born 1914.
The Etcher (2nd Plate)
Etching
1930s

No. 66
LAWRENCE KUPFERMAN. American, born 1909.
The Printer
Drypoint
1937

. **No. 67**
KEITH SHAW WILLIAMS. American, 1906–1951
Stow Wengenroth Making a Print
Etching
1939

No. 68
ELLISON HOOVER. American, 1888–1955.
George C. Miller, Lithographer
Lithograph
1949

No. 69
A. PAUL WEBER. German, born 1893.
Die Exclusiven (The initiated)
Lithograph
1959

No. 70
PHILIPPE MOHLITZ. French, born 1941.
Les impenitents (artiste et amateurs)
Etching
1970

INDEX OF ARTISTS

The numbers refer to catalogue numbers of the artists' works.